IMAGES
of America

BLUFF PARK

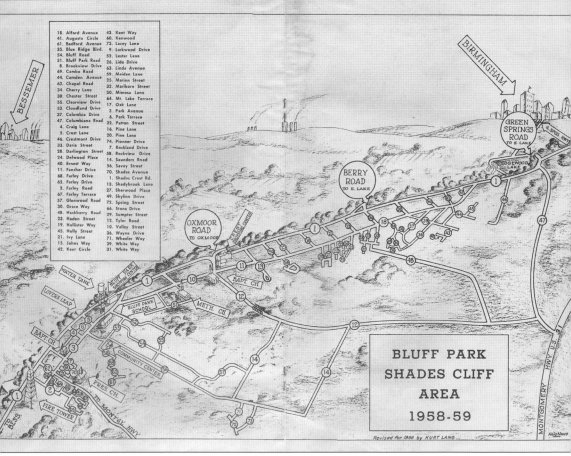

18. Alford Avenue	43. Kent Way
41. Augusta Circle	60. Kenwood
61. Bedford Avenue	73. Lacey Lane
35. Blue Ridge Blvd.	9. Larkwood Drive
54. Bluff Road	52. Lester Lane
51. Bluff Park Road	26. Lido Drive
8. Brookview Drive	49. Linda Avenue
69. Cambo Road	25. Maiden Lane
44. Camden Avenue	25. Marion Street
62. Chapal Road	32. Marlboro Street
34. Cherry Lane	50. Mimosa Lane
38. Chester Street	64. Mt. Lake Terrace
55. Clearview Drive	17. Oak Lane
53. Cloudland Drive	3. Park Avenue
37. Columbia Drive	6. Park Terrace
47. Columbiana Road	22. Patton Street
4. Craig Lane	16. Pine Lane
5. Crest Lane	20. Pine Lane
46. Crestmont Drive	74. Pioneer Drive
33. Daria Street	7. Rockland Drive
28. Darlington Street	58. Rockview Drive
24. Delwood Place	14. Saunders Road
40. Ernest Way	56. Savoy Street
11. Fancher Drive	70. Shades Avenue
68. Farley Drive	1. Shades Crest Rd.
65. Farley Drive	13. Shadybrook Lane
2. Farley Drive	27. Sherwood Place
67. Farley Terrace	42. Skyline Drive
36. Glenwood Road	72. Spring Street
30. Grace Way	66. Stone Drive
48. Hackberry Road	29. Sumpter Street
23. Haden Street	12. Tyler Road
19. Hollister Way	10. Valley Street
45. Holly Street	36. Wayne Drive
21. Ivy Lane	71. Wheeler Way
15. Johns Way	39. White Way
42. Kent Circle	31. White Way

BLUFF PARK
SHADES CLIFF
AREA
1958-59

Revised for 1958 by KURT LANG

MAPMAKER'S VIEW OF BLUFF PARK. This map is the artwork of Kurt Lang. It shows a listing of roads and places in Bluff Park including the fire tower that is no longer standing. Lang drew the map for several area directories. This one, from 1958, was found behind a kitchen cabinet by Douglas McLean while he was doing updates to a house. Lang's son now runs the family map store that is still in operation right in the heart of Bluff Park at the Shades Mountain Shopping Center. (Courtesy of Kurt Lang.)

ON THE COVER: THREE GENERATIONS OF BLUFF PARK WOMEN, 1910. Pictured in the summer on the high rocks in front of 645 Shades Crest Road are Ann Susan Hale Copeland (Mrs. Harvey Hill Copeland Sr.) and Sophronia Caroline Marable Hale (Mrs. George Gardner Hale Sr. and mother of Ann Susan Hale Copeland). Ann Susan, 1876–1970, was the first schoolteacher in Bluff Park and taught in the area for 40 years, until the age of 70. Sophronia, 1841–1917, is holding her granddaughter Amarintha "Ammi" Copeland, 1910–1994, the daughter of Ann Susan and Harvey. This photograph was taken at Sophronia's home. (Courtesy of Susan Hale Copeland Kelley.)

IMAGES
of America

BLUFF PARK

Heather Jones Skaggs

ARCADIA
PUBLISHING

Published by Arcadia Publishing
Charleston, South Carolina

Printed in the United States of America

Library of Congress Control Number: 2012948307

For all general information, please contact Arcadia Publishing:
Telephone 843-853-2070
Fax 843-853-0044
E-mail sales@arcadiapublishing.com
For customer service and orders:
Toll-Free 1-888-313-2665

Visit us on the Internet at www.arcadiapublishing.com

*This book is dedicated to Bluff Park and its
people and to my husband and family.*

CONTENTS

ACKNOWLEDGMENTS

I have been researching the history of Bluff Park for BluffParkAL.org for several years. Having grown up in the community, I was well aware of its rich history. I am always amazed at the memories tucked away in the minds of the people here. As years and, unfortunately, people pass on, I have found it of the utmost importance to have a growing, easily accessible, written and pictorial history available. It would not be possible to bring the history of Bluff Park to you without the help of Susan Hale Copeland Kelley, Hale family descendant and family historian. It is a great honor for me to share her family photographs, stories, and written history. I greatly appreciate the trust she placed in me. Without the photographs and manuscript, we would not have some of the only surviving images today. Thank you to the churches for allowing me to dig through their archives and libraries. I also have to thank Mary Tyler Marlow, Robert Tyler, and Bess Hale Hatcher for having me as a guest in their homes for research. Special thanks to Gini Williams, director of the Children's Fresh Air Farm, for pulling scrapbooks and letting me wander around the camp for photographs. Another Hale descendant I must thank is Gregory Evan Thompson, the great-grandson of Evan Presley Hale. His manuscript *The Ancestors and Descendants of Gardner Cole Hale* was a big help in linking all the family stories together for this project. I cannot forget my wonderful husband Greg, who encouraged me to take on the project, saying, "You will do the project right and honor the founding families." Another special thank-you is to Simone Monet-Williams, my editor, who showed me the way through the publishing process. Simone's guidance gave me a clear view of what Arcadia books are about and their place in preserving history. A special thanks to Robin Schultz, founder of BluffParkAL.org. Thank you to all who have allowed me to use your photographs and stories to share Bluff Park, Alabama, with everyone.

INTRODUCTION

Bluff Park is the oldest residential community within the city limits of Hoover, Alabama. Many residents of Bluff Park grew up here, went to college, started families, and returned to the Bluff—including me. I grew up in and around Bluff Park. My husband and I looked at many homes in surrounding communities, but they just did not have the "community feel" that Bluff Park has. So we moved "home." I am very happy to share this community with you in Images of America: *Bluff Park*.

Over 100 years ago, Bluff Park was a vacation and health resort due to its natural spring waters flowing from the mountain. The area has been known by several names depending on who the primary owner of the property was and its use. Before the area was known as Bluff Park, it was called Spencer Springs, named after Octavious Spencer, who built around 40 log cabins and a pavilion in the 1850s. Spencer used the area as a summer resort. Guests could go down from the crest to two natural springs: a Freestone water spring and a Chalybeate water spring. The springs were said to have medicinal value and were popular with resort guests.

The name changed again in 1863 when Gardner Hale, of Prattville, purchased the property. Hale kept the land as a resort area and added to it. He renamed his resort Hale Springs. The Hale name is prominent throughout the history of Bluff Park. Gardner Hale's son Daniel Pratt Hale ran a bed-and-breakfast type establishment called Liberty Hall and another called Pinnacle House. Pinnacle House was on top of the mountain and was used for lodging; it was said to have the best views on the mountain.

As industry grew in the outskirts of the area, the need for more roads became apparent. In 1892, the Hale Lumber Company built an access road over an old wagon trail to transport lumber. This road gave visitors to the resort a way to get up and down the mountain from Oxmoor Valley below. Liberty Hall and Pinnacle house were the main attractions at Hale Springs from 1890 until about 1907. As time went on, visitors and landowners of Hale Springs became more interested in the view from the bluff rather than the springs and their healing properties. Residents of the area started digging wells, thus removing the need to take trips to the springs for water. This was around the time that the name changed to Bluff Park. One account records that the civic club came up with the name as the springs were becoming obsolete and the views of the bluff became the attraction.

After the death of Gardner Hale, part of the land was put up for sale in a public auction. Hale's son, George Gardner Hale, continued the family legacy in Bluff Park by way of his own sons, William, Evan, and George Jr. Called simply "the Hale brothers" by longtime Bluff Park residents, the brothers did a large amount of the home construction along the crest. William, Evan, and George Jr. built several homes on what is now Shades Crest Road for their families. The homes still stand today as part of the Shades Crest Road Historic District as placed in the Alabama Register of Landmarks and Heritage in November 1996. The overseer's home, which was lived in but not built by William Hale, is the oldest historical home in the area at 120 years old. The

first caretaker or overseer of the property on record is William Winsley Morgan, who lived in the house with his wife, Eliza Hale Morgan, and their two sons. Morgan's niece was Sophronia Hale, William Hale's mother. According to the Hale family descendants, the two families swapped homes. The Morgans moved to the Hales' home in Dadeville, Alabama, and the William Hale family moved into the overseer's home. Hale was one of the first overseers of the orchards on the property. As overseer, he would manage the cultivation of trees and the shipping of fruit in season. Some of the stone terraces used in the farming are still visible in the yard and in the yards of adjoining neighbors. After William and Evan married, they built homes for their families on Shades Crest Road. In 1908, George Jr. built a home for his sister Susie on Shades Crest Road next to their mother's home.

The Tyler family, from which Tyler Road gets its name, started moving to Alabama in 1888 when William Marion Tyler came from Georgia to Alabama and purchased land to build a farm and homes. William Marion Tyler's brothers James Henry Tyler and Jobe Tyler also moved to Alabama, buying land and building homes. The Tylers had a dairy farm and grew many types of vegetables. William Marion Tyler married into the Hale family when he wed Mattie Maude Hale in 1891.

In 1907, following the sale of the Hale Springs land, the Bluff Park Hotel Company was formed. It operated from 1911 to 1923 under various owners. A fire destroyed the hotel in 1925 and it was not rebuilt.

Some other families on the bluff were Hanahan, Yates, Northington, Latham, Chambers, and Aldrich. Aldrich Villa was the home of William F. Aldrich. After his death in 1925, the house was rented as a nightclub for a time until it burned down in the late 1930s. The property ownership went to the state of Alabama. A fire tower was put on the property, and it became a well-known landmark in the community. On the same property, there are stone steps that are thought to be left over from the nightclub.

The Dison family moved to the Hale Springs–Bluff Park area and were active in many local activities. They bought land from Dr. Robert Berry, and it was the Dison family that donated land on what is now Tyler and Valley Streets for the first one-room schoolhouse and church. It had become clear that the growing community needed a school for educating the children and a church in which to worship. Many gathered at a brush arbor church on Shades Crest Road or held Sunday school classes in homes.

Ann Susan "Susie" Hale Copeland started the teaching movement on the mountain by first teaching a few students in her home. After she conducted a survey that showed the need for a community school, a one-room church was built in 1896 called Summit Church and School. The school remained here from 1899 until 1923. The school moved to its current site in 1923 and was renamed Bluff Park School. The church changed its name to Bluff Park Baptist and later moved to a new location. Several churches now serve the community. The City of Hoover was incorporated in 1967 and named after William H. Hoover, the founder of Employers Insurance of Alabama. Hoover started as a residential community and grew to a business-booming metropolis. Bluff Park was annexed to the city of Hoover in 1989.

One

THE HALE FAMILY AND HALE SPRINGS

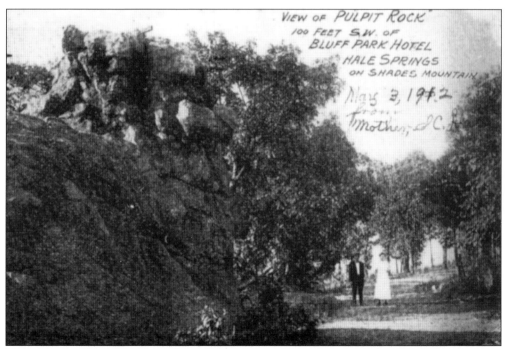

WELCOME TO HALE SPRING ON SHADES MOUNTAIN. This photograph from May 3, 1912, shows the view from Pulpit Rock about 100 feet southwest of the Bluff Park Hotel, which was a popular gathering spot for vacationers. The mountain is approximately 1,100 feet above sea level and 500 feet above Birmingham. (Susan H.C. Kelley.)

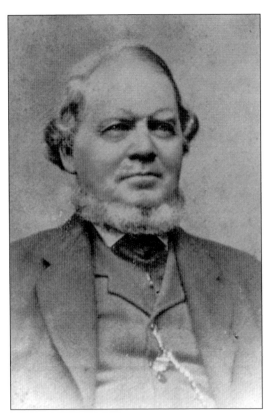

THE FOUNDERS. Gardner Cole Hale ran successful cotton mills in Rhode Island and Massachusetts and became superintendent of the Daniel Pratt Cotton Gin Factory in Prattville, Alabama. Pratt made a deal with Hale for him to go to England and buy the most modern equipment for his mill in Autauga Creek. Hale agreed. This was a big change for the Hale family, Gardner, and his wife. Below, Ann Susan Ballou, of Rhode Island and a Mayflower descendant, went to Manchester, England, with her husband in 1866 to buy the machinery. Between 1859 and 1863, Hale purchased the Spencer Springs property from Octavius Spencer and renamed the area Hale Springs. In 1880, Hale died and his children managed the resort that would later become Bluff Park. The Hale families did much of the development in the area. (Susan H.C. Kelley.)

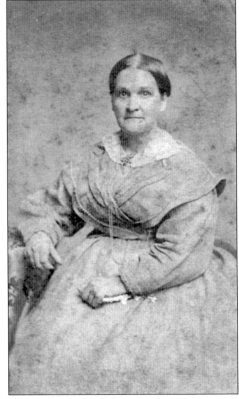

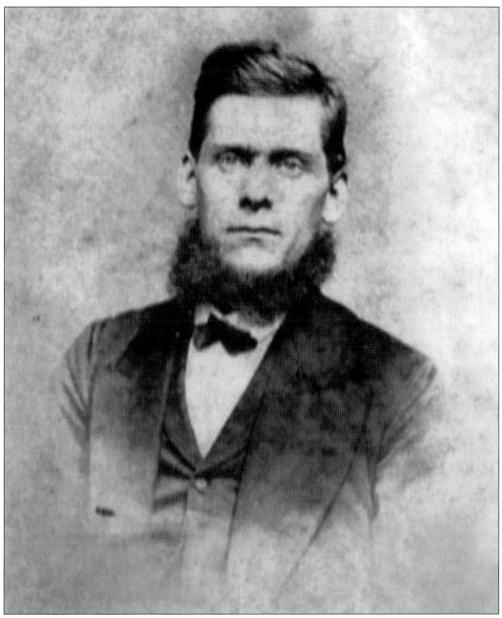

GEORGE GARDNER HALE SR., 1837–1889. Born in Providence, Rhode Island, Hale moved to Alabama with his family when he was 10 years old. As a child, he worked on building plank roads in Montgomery. He was also a Pony Express mail carrier on the stagecoach route and later learned how to run a cotton mill. Hale also enlisted in a Civil War cavalry regiment in Prattville, the Prattville Dragoons, but was honorably discharged to run the Dadeville Cotton Mill to make uniforms for soldiers. While in Dadeville, Hale met his wife, Sophronia Marable, and worked in her father's sawmill. In 1865, Hale bought an interest in a gold mine in Talladega. Mercury poisoning from the mining caused his health to decline and eventually led to his death. Hale taught his children—Emma, William, Evan, Mattie Maud, Susie, and George Jr.—to have a strong work ethic. It was through this ethic the establishment of Hale Springs–Bluff Park was possible. (Susan H.C. Kelley.)

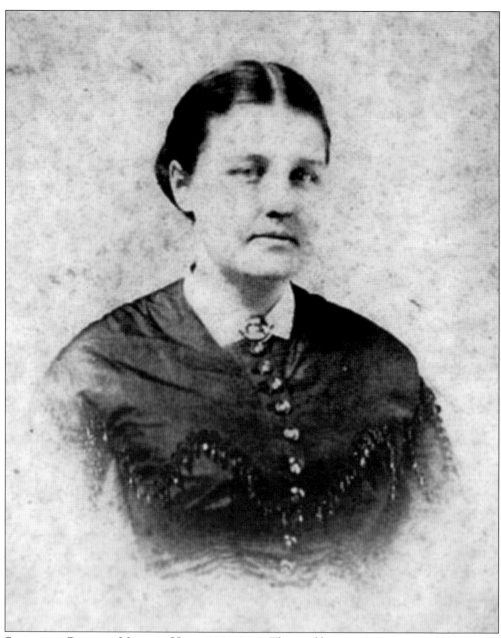

SOPHRONIA CAROLINE MARABLE HALE, 1841–1917. This avid letter-writer is responsible for much of the history of Bluff Park being kept in written form. Marable married George Gardner Hale Sr. in 1864. Due to her husband's paralyzing illness, she had to take over full responsibility of the family lumber mill and large family of six children. Young Emma Hale died of Malaria and was buried in Dadeville. Sophronia stayed in Tallapoosa County, running the farm and caring for her ill husband until his death in 1889. After that, she and the younger children moved to Hale Springs where the oldest sons were already established. A believer in education for all, Sophronia sent her two remaining daughters, Mattie Maud and Susie, to the English and Classical Institute in Montgomery, founded by Susan Frances Hale Tarrant (her sister-in-law) for higher education. The daughters later returned to Hale Springs–Bluff Park to teach (Susan H.C. Kelley.)

DANIEL PRATT HALE, 1849–1922. Daniel Pratt Hale was the 10th child of Ann Susan Ballou and Gardner Cole Hale. Hale and his wife, Annie Marshall Kirkland, had six children and lived on Shades Crest Road like the rest of the family. The original home of D.P. Hale was torn down and now a new home at 713 Shades Crest Road sits in its place. Hale served as proprietor of the Springs at Hale Springs in 1907, running Liberty Hall and Pinnacle House. Below is a campaign flyer for the office of coroner for Jefferson County. Besides working the resort, Hale also filled this role. He was named after Daniel Pratt, his father's employer from the Pratt Cotton Gin and founder of Prattville, Alabama. (Susan H.C. Kelley.)

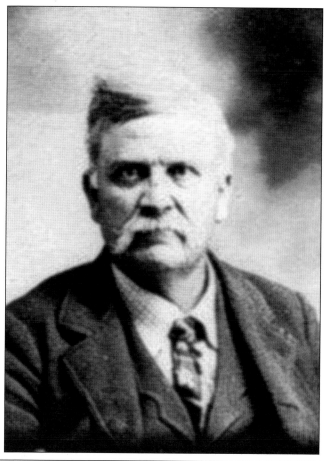

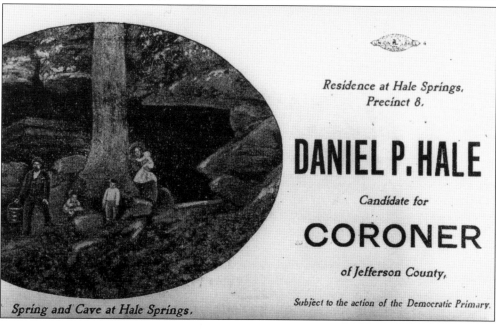

Spring and Cave at Hale Springs.

Residence at Hale Springs,
Precinct 8.

DANIEL P. HALE

Candidate for

CORONER

of Jefferson County,

Subject to the action of the Democratic Primary.

EVAN PRESLEY HALE, 1869–1928. The son of George and Sophronia Hale, Evan was quite an entrepreneur with interests in real estate and coal mining. Hale also owned a sawmill business and built homes in Bluff Park. He served as a deacon in his church, Summit/Bluff Park Baptist. The middle name "Presley" was from his grandmother Emily Presley, who was related to Elvis Presley. (Susan H.C. Kelley.)

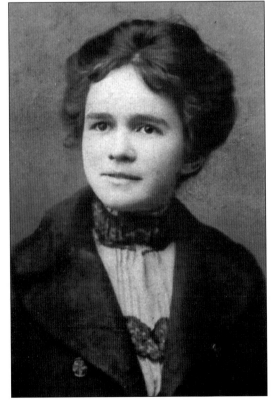

MINNIE EDWARDS CROSS HALE, 1876–1959. Minnie married Evan Presley Hale in 1895. Both were charter members of Summit/Bluff Park Baptist. Minnie was also a lifelong member of the Women's Club of Birmingham and later became a member of Woodlawn Baptist Church. The couple had six children: Nellie (who died young), Evan Presley Jr., Gardner Semmes, Catherine, Minnie Edwards, and Eula. (Susan H.C. Kelley.)

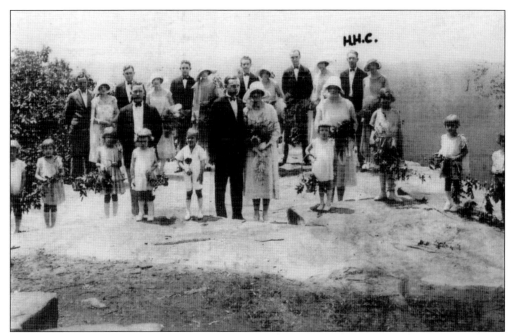

WEDDING ON SUNSET ROCK, 1924. Pictured here at their wedding held on Sunset Rock are Minnie Hale and Melvin Ennis. Minnie is the daughter of Evan P. and Minnie Edwards Cross Hale. The four flower girls, Hannah, Carmelite, Leverne, and Margaret held garlands of flowers. Mary and Martha Dabney held hand-painted baskets, and violinist Kathleen Simmons played before the wedding. Standing in the back is groomsman Harvey Hill Copeland Jr. (Susan H.C. Kelley.)

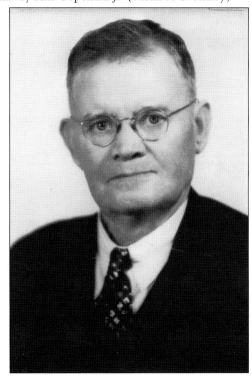

WILLIAM MARABLE HALE, 1867–1944. Best remembered through his letters, William Marable Hale was quite a businessman and was a darling big brother to his sisters. Hale married Mary Elizabeth "Bessie" Jones in 1890. Their children were Emma Sophronia, Eunice Lee, Vivian Jones, Hannah, William Jr. (who died at the age of one), Charles Henry, Mary Elizabeth, Oswald Beale, and Annie Ruth. (Susan H.C. Kelley.)

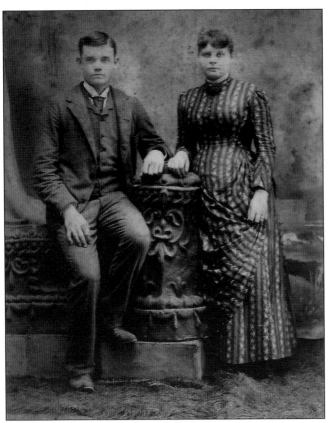

WILLIAM MARABLE HALE AND SISTER MATTIE MAUD HALE, 1888. Pictured here with her brother is Mattie Maud Hale (1872–1902). Mattie married William Marion Tyler (1869–1955) on Nov. 26, 1891. She died after giving birth to the last of their four children. Tyler remarried Mary W. Hagins, whose daughter Irene (from a previous marriage) became a teacher at Summit School (Susan H.C. Kelley.)

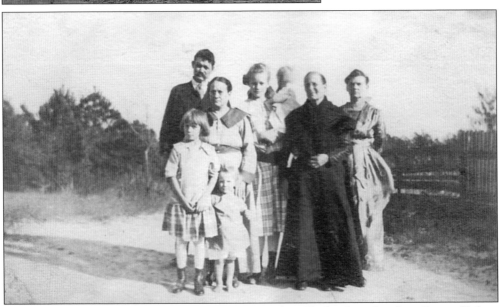

WILLIAM MARABLE HALE AND FAMILY, 1902. Pictured on Shades Crest Road are Eunice Hale at front left holding her little brother Vivian's hand. From left to right in the back are William M. Hale, Mary Elizabeth ("Bessie") Jones Hale, and Emma Hale holding little brother Charles. Also identified are Sara Hicks and Mrs. W.M. Tyler. (Bluff Park Baptist Church.)

ANOTHER HALE FAMILY PHOTOGRAPH.
Pictured here on Shades Crest Road are
Evan Presley Hale and his wife, Minnie
Edwards Cross Hale, in front of their
home. The house was part of a row of
homes that were built by the Hale brothers
for their families (Susan H.C. Kelley)

SUSIE AND FRIEND, 1910. Pictured here are Ann Susan "Susie" Hale Copeland and friend Eula
Atkinson standing on the rocks between Susie's house on Shades Crest Road and her mother
Sophronia's house, also on Shades Crest Road next door. Family photography was popular on
the boulders of Shades Crest Road. Hopefully no one ever fell off the popular rock formations.
(Susan H.C. Kelley.)

HARVEY HILL COPELAND SR. AND ANN SUSAN "SUSIE" HALE COPELAND. Ann Susan "Susie" Hale (left) was the daughter of George Gardner and Sophronia Hale. Susie went to Florence State Teacher's College where she met her husband, Harvey Hill Copeland Sr. (below), a graduate of Northwestern University and pharmacist from Brundidge, Alabama. The two married in 1904 and ran a family drugstore in Birmingham called Copeland's Drug Store. With her background in education, Susie Hale Copeland taught children in the community and started the first classroom-teaching environment on the mountain. She became the first teacher of Bluff Park School. She taught for 40 years in Birmingham and Jefferson Counties and was a charter member of Chapel in the Pines Presbyterian Church in Bluff Park. (Susan H.C. Kelley.)

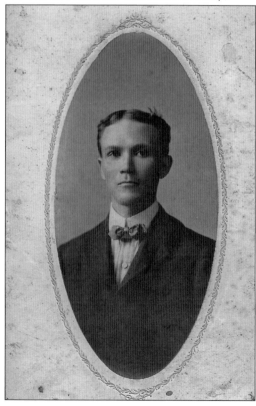

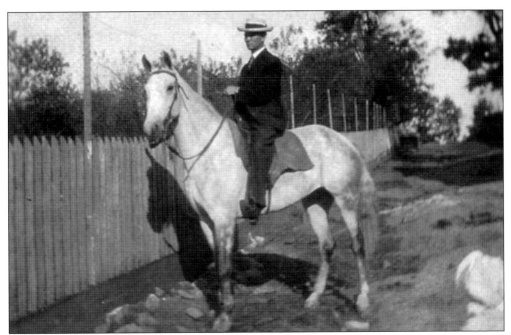

RIDING A HORSE TO WORK. Horseback was a popular way to travel down the mountain to the Oxmoor Valley. Notes on the back of this photograph state that Harvey Hill Copeland Sr. was leaving for the city after renting a horse from Fies Stables. Note baby daughter Carolyn Copeland in the corner, going to her father. (Susan H.C. Kelley.)

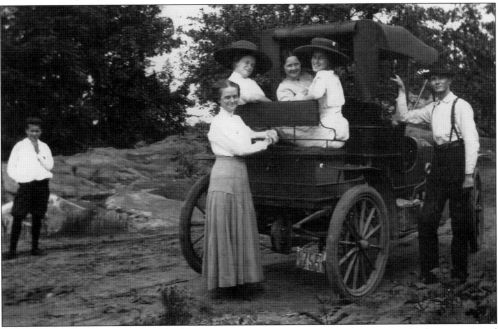

THE COPELAND FAMILY CAR, 1910. Pictured here with the family car on a dirt Shades Crest Road are Evan Presley Hale Jr. and Emma Hale Dabney. Susie Hale Copeland is in the middle; proudly standing beside his 1910 Stanley Steamer is her husband, Harvey Hill Copeland Sr. In the shadows of the front seat with his mother, Susie, is Harvey Hill Copeland Jr. (Susan H.C. Kelley.)

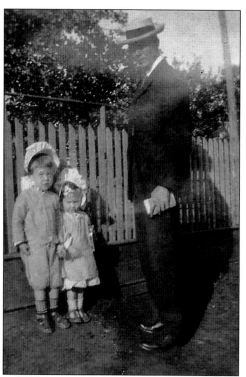

STANDING WITH DAD AT THE BARN. This photograph, taken in 1909, shows Harvey Hill Copeland Sr. with his son Harvey Hill Jr. and daughter Carolyn posing in their cute outfits outside the picket-fence gate of a barn. Perhaps they were going to rent a horse to take down the mountain. (Susan H.C. Kelley.)

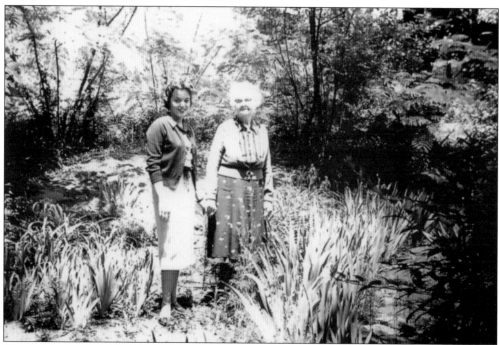

GRANDDAUGHTER AND GRANDMOTHER, 1959. Pictured here standing in her front yard are Susan Hale Copeland Kelley (left) and her grandmother Ann Susan "Susie" Hale Copeland. The bluff was an ideal place for family photographs and event pictures. Many in the Kelley collection are from bluff scenes. (Susan H.C. Kelley.)

Two

THE RESORTS

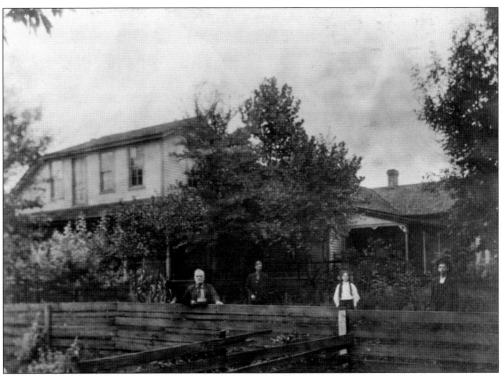

ESCAPE TO THE MOUNTAINS. The place to stay when people wanted to escape from the city was Pinnacle House at Hale Springs–Bluff Park. Pinnacle was a boarding house run by Daniel Pratt Hale; the figure standing at the fence is thought to be him. Around 1907, Pinnacle was torn down to make way for the Bluff Park Hotel. (Birmingham, Ala. Public Library Archives, File #1427.19.)

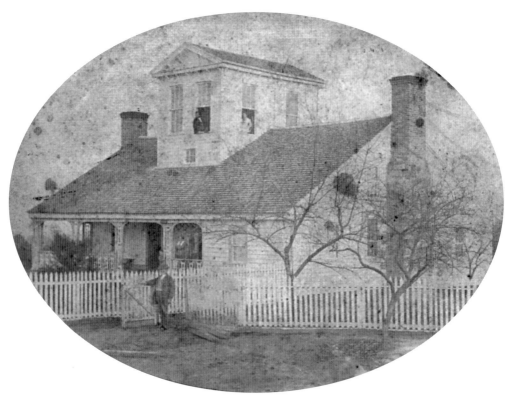

LIBERTY HALL, 1892. The Hale Lumber Company built an access road on an old wagon trail to transport lumber. The road gave visitors to the resort, now owned by Hale, an easier way to get up and down the mountain. Liberty Hall and Pinnacle House were the main attractions at Hale Springs from 1890 until about 1907. Liberty Hall (pictured) also called the Gardner Hale Home, was part of Spencer Springs Resort when Gardner bought the acreage in 1863. Hale never changed the name of the house and continued to take in boarders. Pictured in this photograph are Gardner Cole Hale standing at the carriage gates, Hannah Hale on the front porch, and possibly George Gardner Hale and his wife, Sophronia Hale, at open windows in the observatory. When Hale died in 1880, his daughter Hannah Hale continued to live in the house and took in boarders as well. The home was torn down around 1912 after the Bluff Park Hotel was built, making way for a dance pavilion and expansion of the hotel. (Susan H.C. Kelley.)

ROCK FORMATIONS, 1890. Natural rock formations were all over Hale Springs–Bluff Park. Both of these along Shades Crest Road were widely used as attractions and for photographic opportunities. The view above looks south down Shades Crest Road, at Balanced Rock. The gentleman sitting on top in the center was quite a sight. Surprisingly, the rock never fell until modern widening of the road caused it to be blasted down the side of the mountain. Pulpit Rock, seen in the left background above, was also a great site for photography. The view below looks north down Shades Crest Road; it is a close-up of Pulpit Rock with two visiting ladies, one identified as Mrs. Kitchella and the other unidentified. In the background is Liberty Hall, the popular boardinghouse. (Susan H.C. Kelley.)

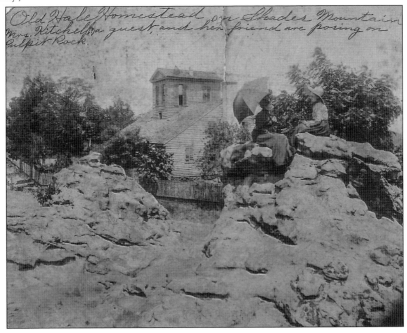

A VIEW FROM THE BLUFF. The *Hale Springs Ledger* provides a rare look inside the memories from visitors to Hale Springs in the early 1900s. In it are countless reports from families, groups, and government officials who recount their time on the bluff. The atmosphere is described as pure

as the crystal streams that burst from the mountain crevices. A view from this elevation allows one to take in the beauty of nature as one hill and mountaintop rolls into another. Imagine this view from outside a guest room window! (BluffParkAL.org.)

THE VIEWS ARE STILL HERE. Even today, the views of the bluff captivate the people of Bluff Park. Many homes on the bluff of Shades Crest Road have observatories to climb to the top and sit and watch the sunset as it sinks below each ridge. The colors of the seasons paint across the view like a picture-perfect kaleidoscope of forest greens in spring to warm orange, browns, and

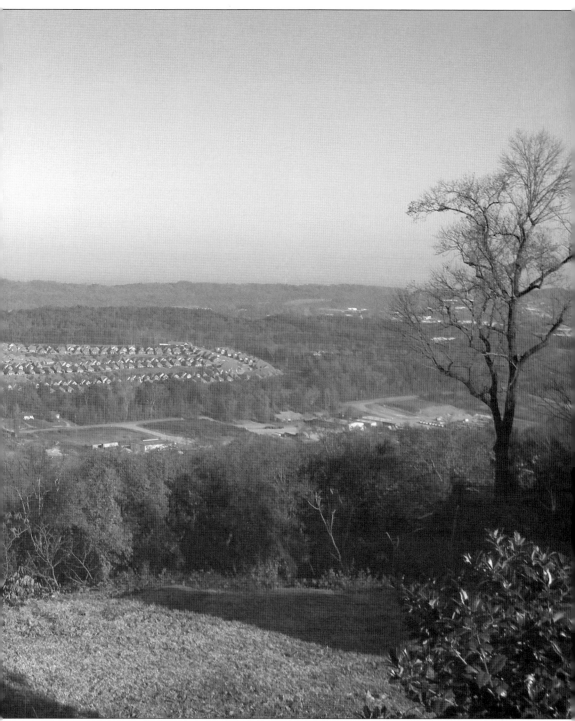

yellows in the fall. Today, the view over the valley is open to the development in the Oxmoor Valley, as well. New subdivisions, golf trails, and roads are tucked into the still-thick forest of the valley. (BluffParkAL.org.)

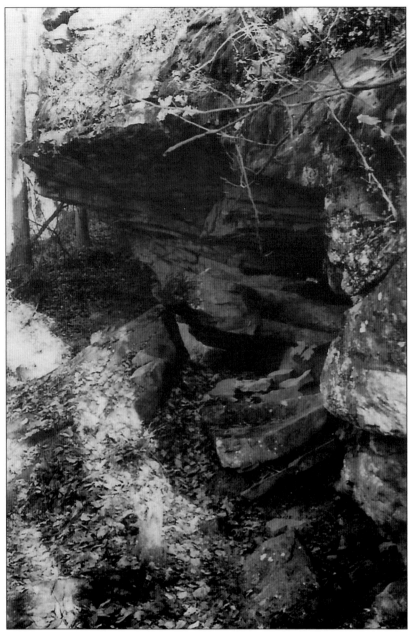

No Running Water but Natural Springs, 1890. The two springs that run under the bluff are known as the Freestone and Chalybeate Springs. Both gave pure, healthy water. The Freestone water came from between the rocks as it trickled down the bluff and could be reached only by winding footpaths. The Chalybeate Spring was further down the ridge and the path was steeper. These springs furnished all the drinking water used by people in the area. For domestic purposes, barrels were arranged to conserve rainwater from the roofs of homes. Some of the more lavish homes had large cistern tanks with charcoal filtration to clean the water from the roofs. Young members of the families would set out on the path early and late with water pails to fill cedar buckets and sometimes coolers with faucets. These are the accounts of Ann Susan Hale Copeland from her manuscript *Early Memories of Bluff Park Region*. (Susan H.C. Kelley.)

THE NATURAL SPRINGS TODAY. Some people would keep milk and other perishables in the cool rock cave under the springs since refrigeration was not available. It is a good thing there is running water and refrigerators today because it is very difficult to reach the springs now. These photographs were taken in 1983 at a time when the path to the springs was not as overgrown as it is now. They show the now slow-flowing stream of natural spring water. In historic times in Bluff Park, the springs were a source of fresh water for the community, but now they are an attraction for rock climbers. The area around the cave and springs is a popular geocaching spot for caching enthusiasts. The coordinates for one such cache are 33° 24.719 N, 086° 51.460 W. (Susan H.C. Kelley.)

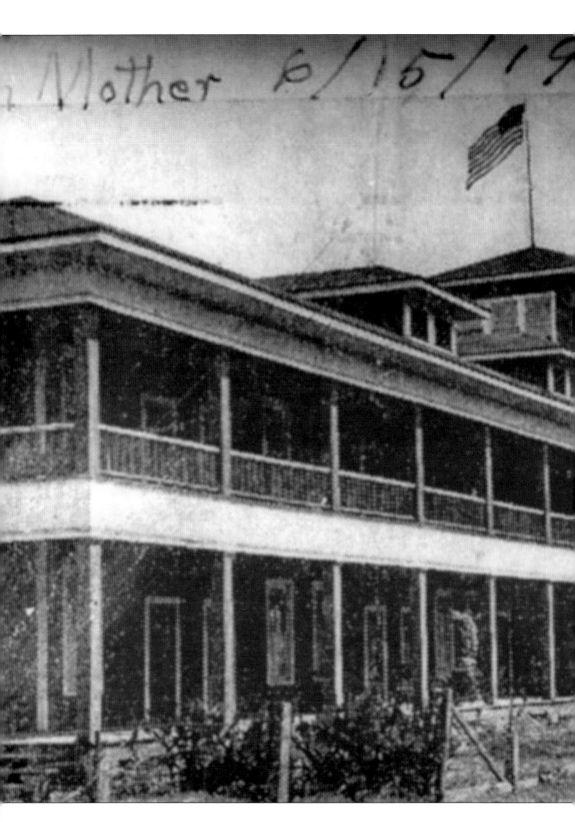

THE BLUFF PARK HOTEL. The Bluff Park Hotel Company was formed in 1907. Under the leadership of J.A. Yates, the company bought six acres of land for the hotel. The hotel consisted of 20 rooms that opened up to a porch where guests took in the view of the bluff. It also had a pavilion for entertaining, a dining room, and a third-floor observatory to look out over the mountain. From 1911 to 1923, the hotel changed ownership several times. After World War I, resident Mrs. F.D. Gamble occupied the hotel until 1923, at which time the building was boarded up. The hotel changed ownership again to William Levi and C.P. Campbell, who remodeled it in preparation to reopen it in 1925, but the hotel caught fire and burned to the ground. (Susan H.C. Kelley.)

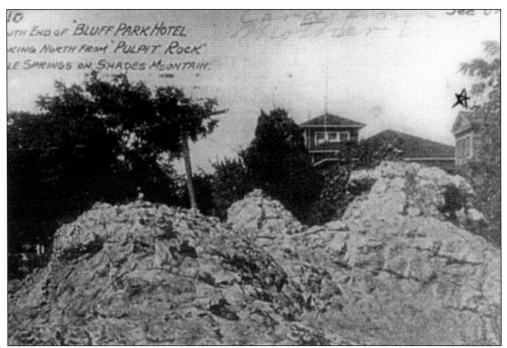

TH END OF "BLUFF PARK HOTEL
KING NORTH FROM "PULPIT ROCK"
LE SPRINGS ON SHADES MOUNTAIN.

BLUFF PARK HOTEL AND LIBERTY HALL. This photograph is a one-of-a-kind from the Hale family, dated 1910. Pictured at right is Liberty Hall/ The Gardner Hale Home, with the Bluff Park Hotel in the background. This is looking north from Pulpit Rock where guests used to climb and enjoy the view of the valley. (Susan H.C. Kelley.)

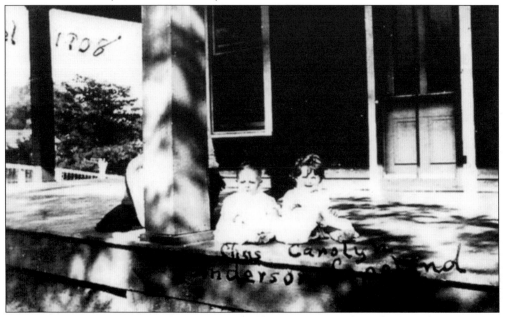

PORCH WITH ANDERSON AND CAROLYN, 1908. This is a rare up-close photograph of the Bluff Park Hotel. Here is little Carolyn Copeland and Charles Anderson sitting on the front porch next to one of the stately columns. Noted on the back of the photograph is that there is a nurse hiding behind the column. (Susan H.C. Kelley.)

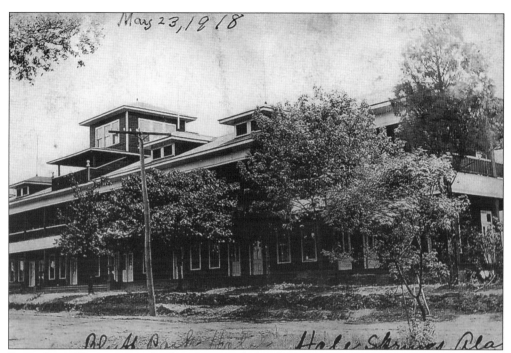

BLUFF PARK HOTEL, 1918. In this photograph dated May 23, 1918, one can see the observatory that was popular for taking in the fresh air and views of the mountain. An old-fashioned power pole sits in the middle and what is thought to be lightning rods extend from each gable. (Susan H.C. Kelley.)

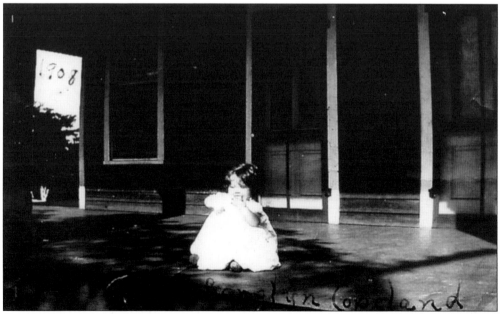

CAROLYN ENJOYING THE BLUFF PARK HOTEL. Here is another nice porch shot of the Bluff Park Hotel. Little Carolyn Copeland is sitting in her pretty dress on the front porch. The hotel was walking distance for many members of the community. What must she be thinking? (Susan H.C. Kelley.)

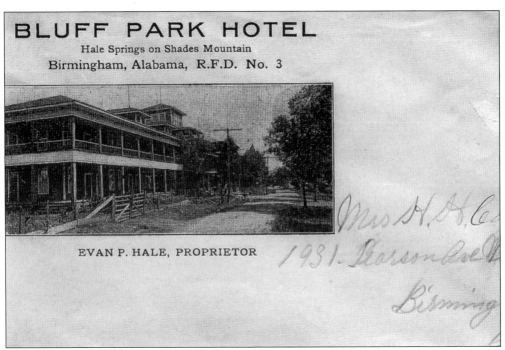

BLUFF PARK HOTEL
Hale Springs on Shades Mountain
Birmingham, Alabama, R.F.D. No. 3

EVAN P. HALE, PROPRIETOR

Mrs H. H. C.
1931. Pearson Ave
Birming

Save Everything! This is a saved envelope from the Bluff Park Hotel used to send a letter to Mrs. Harvey Hill Copeland from her mother on Feb. 17, 1912. Today, people just toss away envelopes as trash; it is lucky that the Copelands saved this rarely-seen paper. The Bluff Park Hotel burned down when Harvey Hill Copeland Jr. was about 20 years old. Copeland, a man who saved everything, went into the burned-out hotel and rescued the fireplace mantel. The mantel is no doubt the largest item from the hotel, which was so popular on the mountain. It now belongs to Susan H.C. Kelley. Kelley plans to one day put the old mantel in her home on Shades Crest Road. (Susan H.C. Kelley.)

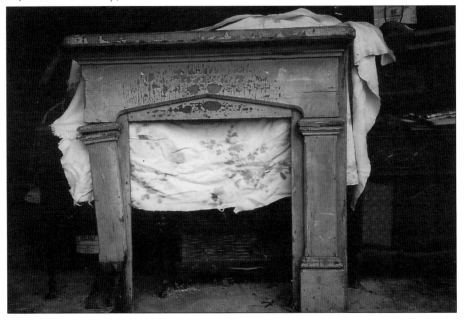

Three

THE HALE BROTHERS AND THE HOMES THEY BUILT

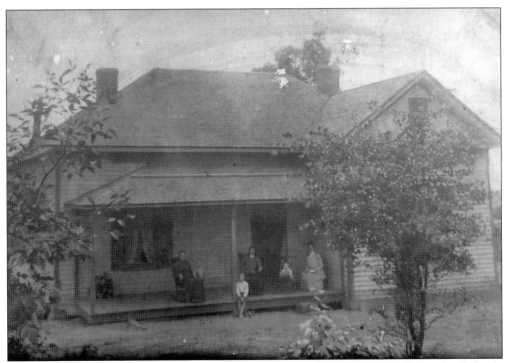

HALE FAMILY PHOTOGRAPHY, 1900s. This home was built between 1902 and 1904 by the Hale brothers for their mother, Sophronia, after the family moved out of the overseer's home. Pictured here is the family on the front porch as it originally stood with a dirt driveway. (Susan H.C. Kelley.)

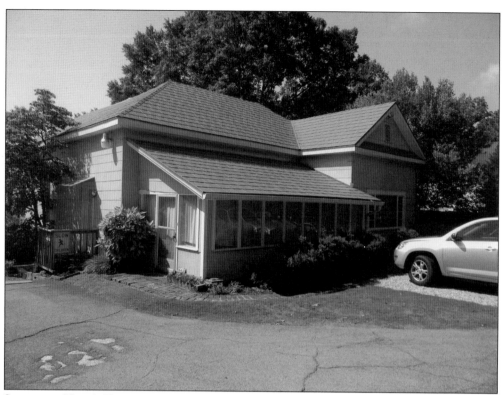

SOPHRONIA HALE'S HOME, 645 SHADES CREST ROAD. The brothers used lumber from their lumber mill to build the home. In the 1930s, according to files from the Hoover Historical Society, a dress shop was established here. Bessie Bodey, the owner of the home at the time, made custom-tailored dresses. In 1975, Frances Armstrong bought the house and opened Frances's Dance Studio. Today, USA Martial Arts teaches karate classes in the studio at the house. The home is included in the Shades Crest Historic District (Susan H.C. Kelley and BluffParkAL.org.)

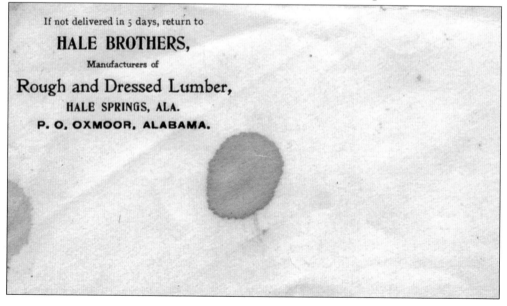

"Susie" and her Home. Pictured standing in front of her home in 1909 is Susan "Susie" Hale Copeland and her cousin Ann Susan Hale (1869–1959). Commonly referred to as "the Yellow Cottage," this historical home was built as part of a bargain between mother and daughter. In 1908, Sophronia Hale told her daughter Susie that if she would build a house next to hers, she would give her the land on which to build it. Below, Susie's ever-loving brother George Gardner Hale Jr. (1878–1968), pictured here in a family photograph in his suit and tie, built the home for his sister. George Gardner Hale Jr. used heart pine wood, a popular type of wood at the time, from the Hale brothers' lumber mill to build the cottage. (Susan H.C. Kelley.)

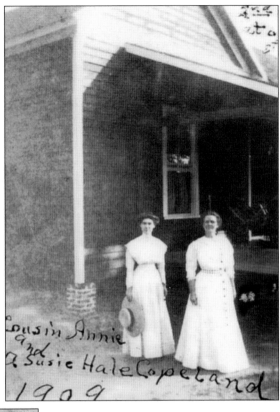

Cousin Annie
and
Susie Hale Copeland
1909

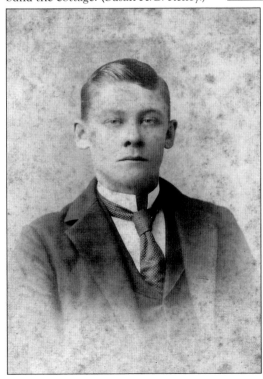

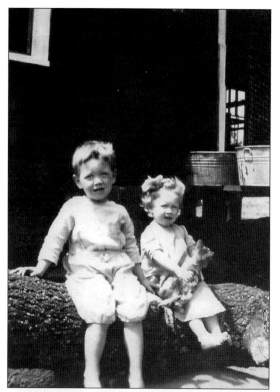

THE ANN SUSAN "SUSIE" HALE COPELAND HOUSE, 641 SHADES CREST ROAD. Pictured sitting on a fallen tree at the family home are Harvey Hill Copeland Jr. and little Carolyn Copeland Bacon with her cat in her lap. The cottage had 12-foot-tall walls, and the boards were stacked one on top of the other. The home had only three rooms, a dogtrot hallway, a porch, and an outhouse. With a picket fence to separate the front porch from the road, it was quite a summer cottage for the time. The home was passed down through the years in the family and is now owned by Sophronia Hale's great-granddaughter Susan Hale Copeland Kelley. It is the only original Hale home still owned by the family. (Susan H.C. Kelley and BluffParkAL.org.)

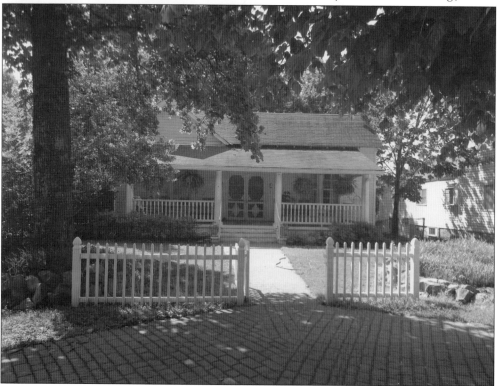

THE HALE TAYLOR HOME, 637 SHADES CREST ROAD. This Williamsburg-style home was completed in the early 1900s by William M. Hale and was connected to the home next door, 633 SCR, by a dogtrot hallway. In the early 1930s, the two houses were cut apart. One of the later prominent owners of the home was Hugh Eddie Gilmore, former Jefferson County commission president. In 1970, Mr. and Mrs. Sterling Taylor bought the property. The home then went to their son Thomas S. Taylor. Thomas, an architectural inspector, removed the screens from the porch and made additions to the home including a second living area. After Thomas's death, his daughter Connie Buchanan assumed ownership and now rents out the property. (Connie Buchanan and BluffParkAL.org.)

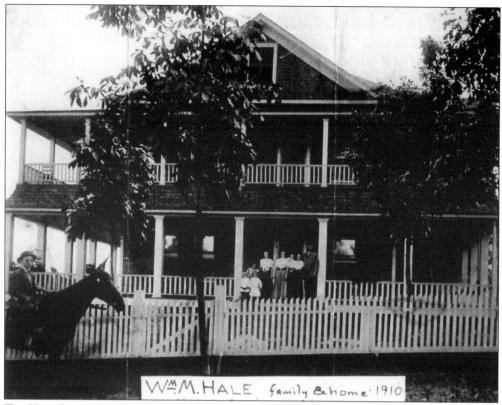

WᴹM.HALE family & home 1910

THE HALE-JOSEPH HOME, BLUFF ROAD, 1910. This home was built in the Hale Springs resort area among the orchards in 1909 by William and Evan Hale. It was originally a two-story farmhouse with double porches sitting on 400 acres. The home was constructed from wood that came from the sawmill of the Hale Lumber Company, also owned by the brothers. Pictured here on the front porch are (first row) Oswald Beale Hale and Mary Elizabeth "Libba" Hale Nabors; (second row) Charles Henry Hale, Eunice Lee Hale Avery, Emma Hale Dabney, Mary Elizabeth "Bessie" Jones Hale holding baby Annie Ruth Hale Hutcheson, and William M. Hale. Vivian Jones Hale is on the horse. Seen below, from the backside of the home, are the porches that were later removed. (Susan H.C. Kelley.)

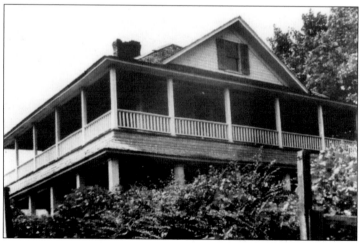

THE JOSEPH FAMILY, 2007. Alabama governor George Wallace's daughter Bobbie Jo Wallace-Parsons and her family owned this home until 1993 when they sold it to Carlo and Diane Joseph. Carlo grew up in Bluff Park, attending Bluff Park School as a child. Not every kid can say he or she found a dream home while walking to elementary school. Carlo walked past the house every day going to school and knew someday he would live there. Pictured at right on their front porch are Carlo and Diane, owners of the Hale-Joseph Home. The home was listed with the Jefferson County Historical Commission in 1993. (BluffParkAL.org.)

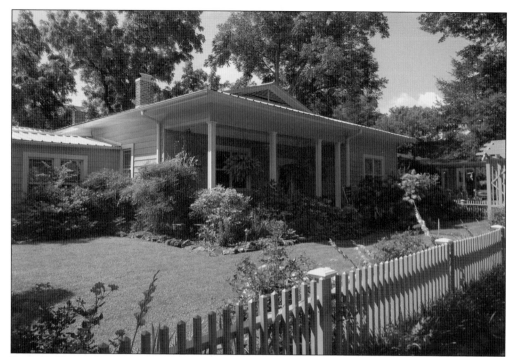

Evan P. Hale's Home, 625 Shades Crest Road. This is the home of Evan and Minnie Hale. The bungalow-style home was built around 1899–1902. The home remained in the Hale family until 1926 and had beautiful views of Oxmoor Valley. Hale's daughter Eula would spend time going down to the springs with her friends. In the 1950s, an extra room and bathroom were added. (BluffParkAL.org.)

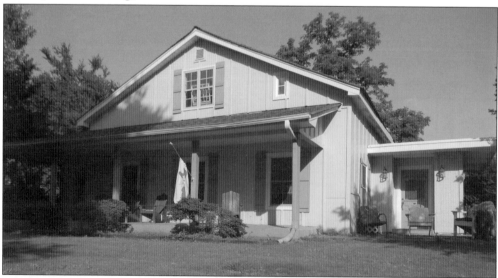

633 Shades Crest Road. Previously attached to 637 Shades Crest Road by a dogtrot hallway, the homes were later cut apart to become separate residences. Malcolm Bethea and his family was one of the notable residents of this home. Bethea, a local dentist, had sons who served in the Alabama state legislature, while his wife was one of the founders of the Shades Crest Garden Club. (BluffParkAL.org.)

Four

THE TYLER FAMILY AND
THEIR DAIRY FARM

THE TYLER FAMILY AND BLUFF PARK. Another one of the founding families in Bluff Park is the Tyler family. Pictured here are Robert Hagins Tyler and his wife, Clara Mae Woolverton Tyler. Robert is the son of Irene Hagins and Luther Tyler. The Tylers still live in Hoover not far from their family's original property and farm. (Robert Hagins Tyler Family Photographs.)

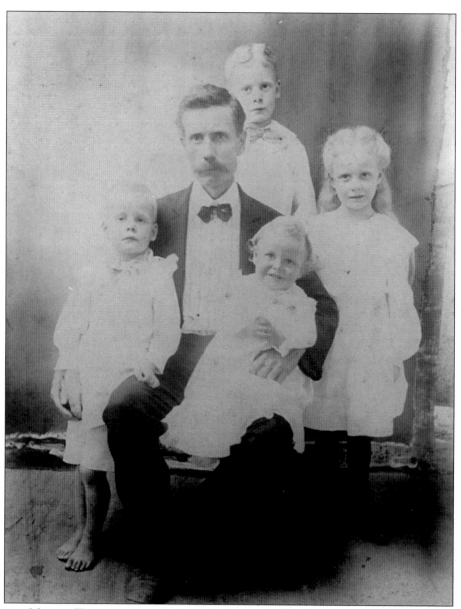

WILLIAM MARION TYLER, 1869–1955. The Tyler history in Bluff Park starts in 1888 when William Marion Tyler of Georgia came to Alabama and bought land at what is now Tyler road. The farm and home he built was located on the corner of Gary Mac Drive and Tyler Road. Tyler had a vegetable farm from which he shared with the community. They also had chickens and cows on the property. Tyler married Hale daughter Mattie Maude Hale in 1891. Their four children—Cecil Hale Tyler, Lillian Tyler, Henry Luther Tyler, and Harvey Milner Tyler—grew up and attended school on the bluff. After his wife passed away, Tyler married widow Mary Hagins of Columbus, Georgia. Her two children from her first marriage were named Dupont and Irene. Irene finished her education in Georgia and then moved to Summit/Bluff Park where she became a teacher at Summit School. Pictured here are father William Marion Tyler and his children, Cecil Hale, Lillian, Henry Luther, and Harvey Milner. Hagins's daughter Irene later married Luther Tyler. (Robert Hagins Tyler Family Photographs.)

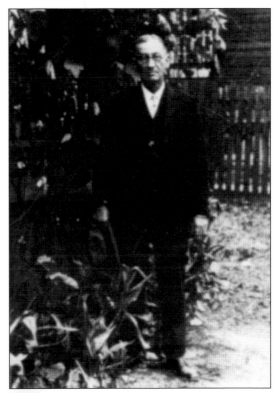

JAMES HENRY TYLER AND SONS. William Marion Tyler's two brothers James Henry Tyler (1867–1935) and Jobe Tyler also came from Georgia to Alabama where they bought land on what is now the Savoy Street area. The Tylers built homes for their families and a dairy farm on the land. The 160 acres of land was bought from the Wheeler family in 1899. James and Jobe divided the land, taking 80 acres each. James Henry Tyler married Ola Addie Frances Miller and they had six sons. Pictured below are three of Tyler's sons in their dress clothes: Hugh Tyler, Henry Tyler, and Clifford Tyler. Not pictured are Ernest Tyler and Claude Tyler. The youngest, Perry Tyler, died as a baby. (Mary Tyler Marlow.)

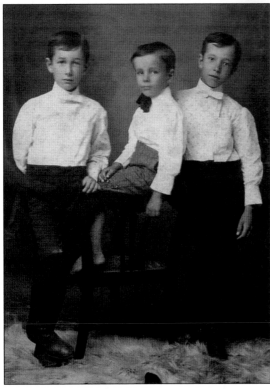

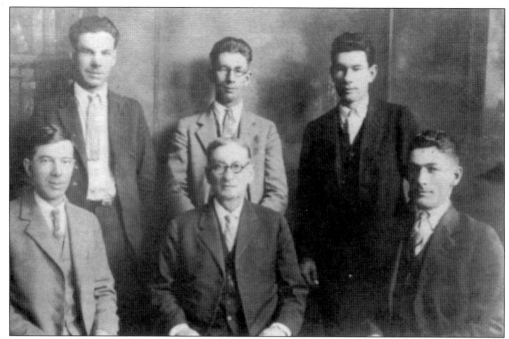

TYLER FAMILY. Pictured here are the children as adults. In the middle of the first row is James Henry Tyler sitting with Hugh and Clifford. In the second row are Henry, Claude, and Ernest. James's brother Jobe and his family—Gladys, Vera, James, Alice, Florence Margaret, and Virginia—also lived in Bluff Park. Their home was on the dairy farm land at approximately the 2400 block of Savoy Street. (Mary Tyler Marlow.)

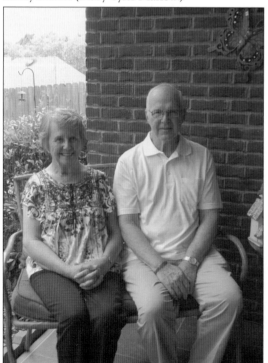

MARY TYLER MARLOW AND HUSBAND ALPHUS MARLOW, 2012. Pictured here at their home in Alabaster, Alabama, are Mary and Alphus Marlow. Mary is the granddaughter of James Henry Tyler and the daughter of Claude Tyler. Marlow spent several years researching her genealogy and roots in Bluff Park. The Marlows are still active members of Bluff Park United Methodist Church. (BluffParkAL.org.)

Five

THE SCHOOLS AND CHURCHES

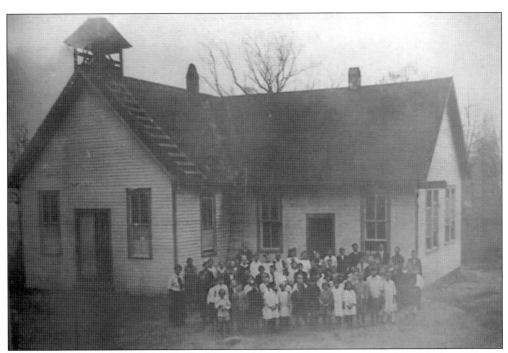

SUMMIT SCHOOL, 1920. In 1899, the Summit Baptist Church joined the Birmingham Baptist Association. At this time, the church and school were in a one-room building at the intersection of what is now Tyler Road, Valley Street, and Alford Avenue. Notice the ladder going up to the schoolhouse bell on the roof. The building was used as both a school and church. (Susan H.C. Kelley.)

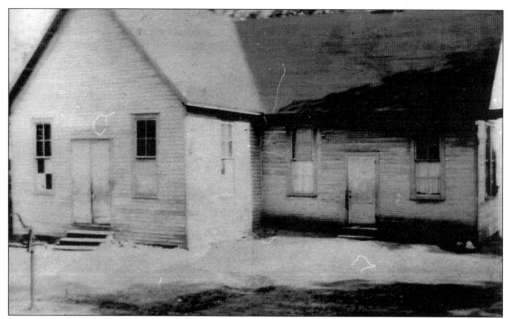

OLD CHURCH AND SCHOOL. This is the original Summit Baptist Church and School pastored by F.H. Watkins. In 1921, the church voted to change its name to Bluff Park Baptist Church. Summit School moved to a new location. On the back of this photograph are notes from Harvey Hill Copeland stating that the left side was the original and the right side was added later. (Susan H.C. Kelley.)

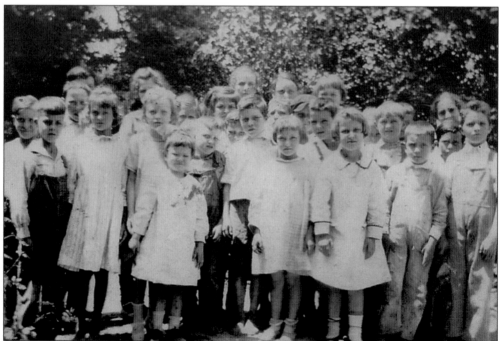

SMALL CLASS. This photograph from 1920 is of a small class from Summit School. The girls are in their pretty dresses and the boys in their overalls. Most children could walk to school and then back home. This is one of the few surviving class photographs. (Bluff Park Baptist Church.)

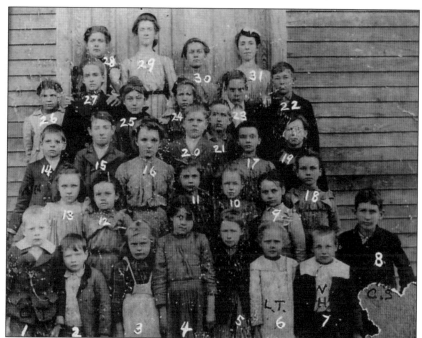

Summit School, 1900–1901. The numbers seen on these photographs are where Harvey Hill Copeland has tried to identify children in the photographs. Pictured above on the front steps of the old school are: 1. Cecil Tyler, Mattie Maud Hale Tyler's son; 5. Eunice Hale, William Hale's daughter; 6. Lillian Tyler, Mattie Maud Hale Tyler's daughter; 7. Vivian Hale, William Hale's son; 10. Emma Hale, William Hale's daughter; 14. Allie Hale; 20. Hillman Hale; 21. and 22. Daniel Pratt Hale's sons; and 23. Luttrell Hale. One of the first teachers at the school was Ann Susan Hale. The picture below has no date but shows Hale, Tyler, Morgan, and other children of founding families in Bluff Park. Also noted are teacher Irene Hagins and students Jewell Morgan, Eula Hale, and Va. Dabney. (Susan H.C. Kelley.)

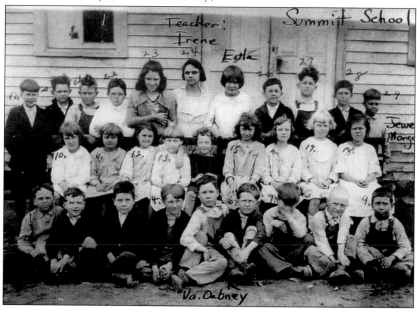

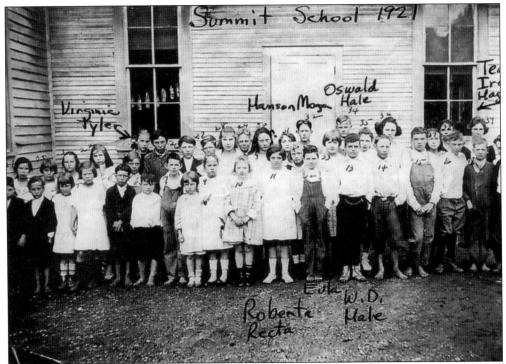

OLDER SUMMIT SCHOOL. This last school photograph from 1921 shows a large class in front of the school house with teacher Irene Hagins. Hagins, who later married a Tyler, kept notes on the history of the church and school that exists today. Identified are some of the children at the school: Virginia Tyler, Hanson Morgan, Oswald Hale, Roberta Recta, Eula Hale, and W.D. Hale. (Susan H.C. Kelley.)

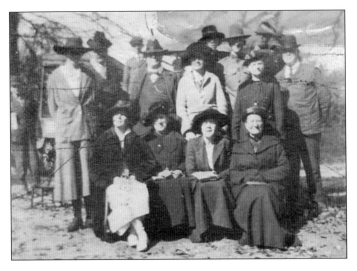

DEACONS AND TEACHERS, 1917. Pictured here are W.M. Tyler, deacon; W.J. Williams, deacon; W.M. Hale, deacon; Dave Sellers; Alec Sellers; Mrs. E.P. Hale; Mrs. W.J. Williams, choir and Sunday school teacher; Mrs. T.L. Moses, pianist and Sunday school teacher; E.P. Hale, deacon; Mrs. W.M. Tyler, Sunday school teacher; Mrs. F.D. Gamble, choir and Sunday school teacher; and Sarah Hicks. (Bluff Park Baptist Church.)

VACATION BIBLE SCHOOL, 1963. Pictured here are students and teachers from the 1963 Bluff Park Baptist Vacation Bible School held at the old church building located at the intersection of Valley Street and Tyler Road. This was the same site as the original Summit Baptist Church. The church was in this location until 1974. (Bluff Park Baptist Church.)

NEW LOCATION GROUND-BREAKING. In 1973, the church started plans for a new building at a new site just a few blocks from the original location. By August 1974, services in the new location on McGwier Drive were held. Seen here, Pastor Richard Trader holds an old-fashioned plow, and members pull with two long ropes during part of the ground-breaking ceremonies on December 16, 1973. (Bluff Park Baptist Church.)

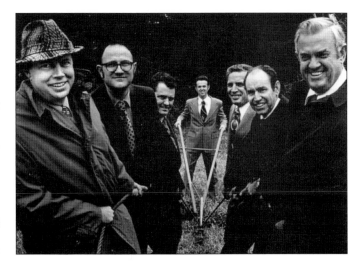

A Cornerstone in the Community. In 2006, Pastor Tony Barber started his work with Bluff Park Baptist. The congregation lives by the motto, "We are a traditional church with contemporary love." The church remains traditional with Sunday worship services and morning Bible study but also serves and cares for the community by opening its doors and hosting community-wide events with a modern, more contemporary feel. Through its 100-plus years in Bluff Park, the Bluff Park Baptist Church has served and shared Christ with the community. In the snow and ice storm of 1982, Bluff Park Baptist Church had power and opened its doors as a shelter to the community. Wicked winter weather, rare for Alabama, hit again in 1993. Unfortunately, Bluff Park Baptist was not able to hold services due to 19 inches of snow! (BluffParkAL.org.)

METHODIST CHURCH ON THE MOUNTAIN, 1912. Methodists on the mountain met with others at the brush arbor on Shades Crest Road. In 1905, some ladies in the community got together and formed the Ladies Aid Society in order to raise funds to start a Methodist church on the mountain. Through the funds raised, land was bought and the Methodist Church on Shades Mountain was formed in 1908. The group, along with other denominations, met at a barn on the property of Daniel Pratt Hale and later moved to a new location. Its first pastors were J.P. Cornelius, J.T. Miller, and J.W. Cary. Pictured here is Bluff Park Methodist church's first building. Built in 1912 in 12 days, it cost around $1,000. In 1925, a two-story building was erected behind the existing sanctuary. (Bluff Park Methodist Church Library Files.)

EXPANSION, 1940S THROUGH 1970S. As the church grew, the need for extra and larger buildings was evident. The first parsonage was built in 1941, located on the site where the Huey-Hudson building (named after Dr. Huey M. Hudson, parish minister from 1969 to 1995) now stands. A new building was constructed in 1949. The sanctuary was finished and the first service was held on Easter morning in 1953. A three-story educational building was constructed at the corner of Church Street and Valley Street in 1959. In 1972, the original wooden church and educational building were torn down and replaced with a gym, parlor, fireside room, and preschool facility. (BluffParkAL.org.)

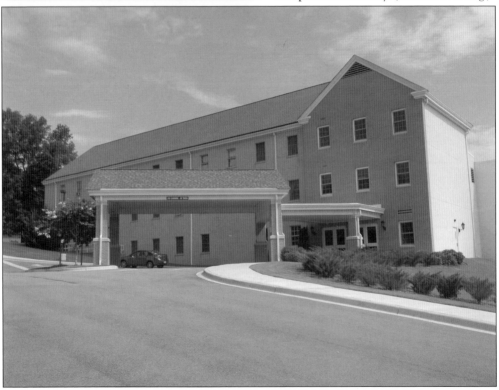

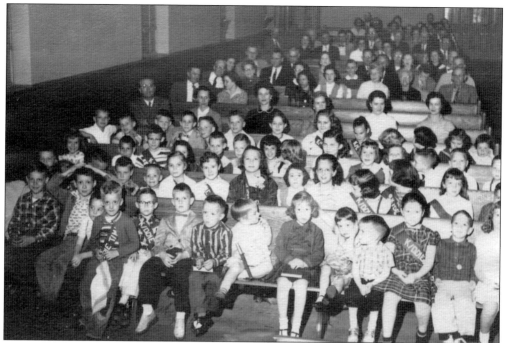

KIDDIE TIME, 1959. This photograph shows children sitting up front with Kiddie Time sashes on. It is unclear what this was, but in later years, at each service there was a special time set aside called "The Children's Moment" during which the pastor or children's director would invite kids to sit in front and hear a Bible story presented on a level that they could understand. (Bluff Park Methodist Church.)

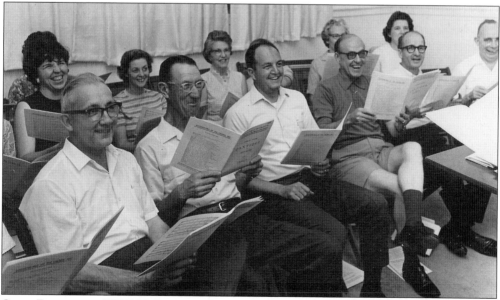

CHOIR PRACTICE AT BPUMC. Preparing for Sunday choir rehearsals are, from left to right, (first row) Cuthel Stewart, Arthur Thomas, Brown Saunders, Henry Ponds, Bob Cahoon, and Gene McLane; (second row) Cary Moore, Gladys Plunkett, Ruth Saunders, Elise Stewart, and Carolyn McCracken. McCracken later became the children's music director. (Bluff Park United Methodist Church.)

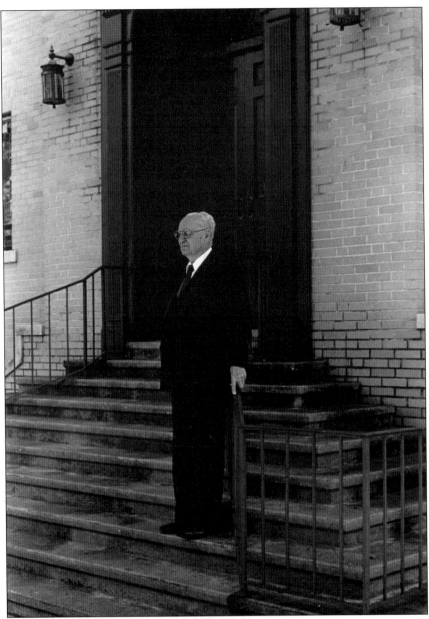

DR. HUEY M. HUDSON. Dr. Hudson came to Bluff Park in 1951 while the congregation was still in the basement of the then unfinished church sanctuary. Dr. Hudson was well known for his successful building programs at each church he was called to—including Oak Ridge, Fairfield, Huffman, and Vestavia—but was even more well known for his personality with the community he served. When new residents moved into the community, Dr. Hudson was one of the first to come say hello and welcome them with his warm and friendly personality. He also always wanted to make sure church property was in good condition. He was known for keeping a toolbox in his church office. Many young couples living in the community today were baptized as children by Dr. Hudson. He started preaching in October 1922 when he was still in high school. He and his wife, Louise, were married more than 60 years, and they had two sons. (Photograph by Patsy Place, courtesy of Bluff Park Methodist Church.)

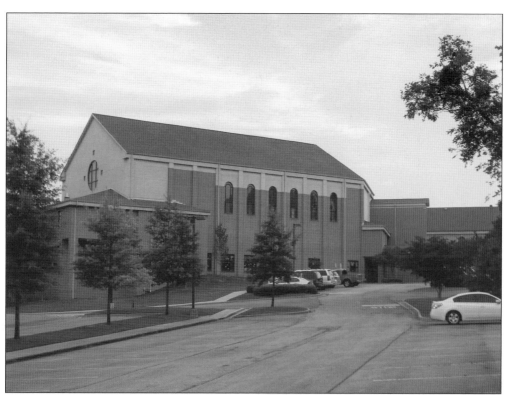

ONE HUNDRED YEARS OF SERVICE IN BLUFF PARK. The congregation found itself outgrowing its facilities again. In 2000, a new building program was started on six acres adjacent to the property for construction of Bluff Park Methodist's third sanctuary, a new fellowship hall, and new preschool building. The old sanctuary is still used for a contemporary service. One special addition is the fully restored pipe organ saved from the old McCoy Methodist Church. The church also has 12 stained-glass windows and a 12-foot rose window. The rose window is in memory of Wilmer and Elizabeth Lacey and shows a vision of the prophet Isaiah, of Christ resurrected and glorified. Rev. Reid Crotty has led the congregation from 1991 to the present day, joined by associate minister Lawton Higgs and parish minister Tom Roberts. (BluffParkAL.org.)

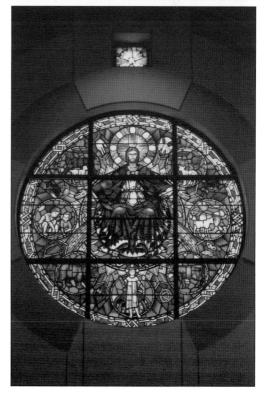

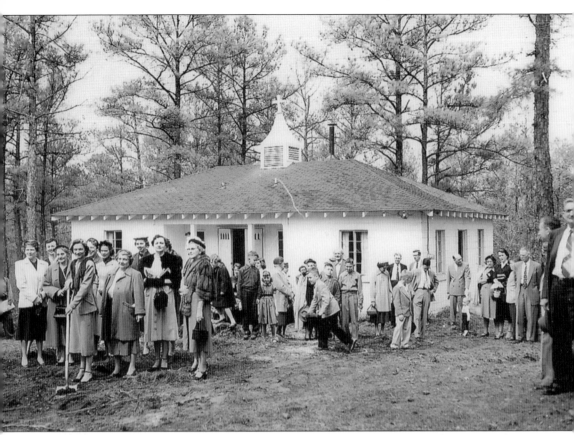

Breaking Ground for the Chapel. In March 1950, members of Chapel in the Pines Presbyterian Church broke ground for the future site of their church in Bluff Park. A year earlier, a small group of people from South Highland Church met in the living room of William Keller on Park Avenue in Bluff Park to discuss the idea of a closer place of worship on the mountain for its community. The small group had been holding Sunday school classes at various homes in the community. A lot on Farley Road was donated by C.H. Chichester and Associates. Construction began in March and in one month the chapel was finished and Sunday school was held in the new building. The name "Chapel in the Pines" was given by a girl named Sandra Evans shortly after the chapel opened. The chapel was ordained and dedicated on Mother's Day, May 14, 1950. The church received its charter and became a fully organized church of the Birmingham Presbytery with 53 charter members and Robert Montgomery the first pastor. (Chapel in the Pines Presbyterian Church.)

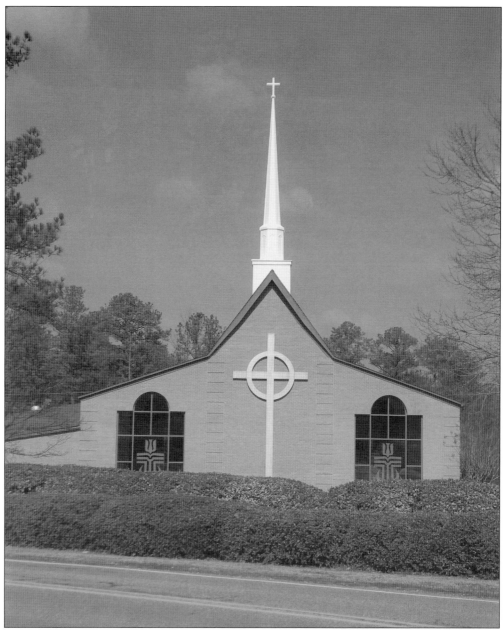

CHAPEL IN THE PINES. Today, Chapel in the Pines continues to be filled with the faces of fellow-seekers. These are hopeful and creative days in the life of the church. The congregants find themselves moving toward a promising future as the halls are filled with the voices of children and young people along with seasoned members of both the church and life. Congregants are involved in meeting the needs of the city and the world. (BluffParkAL.org.)

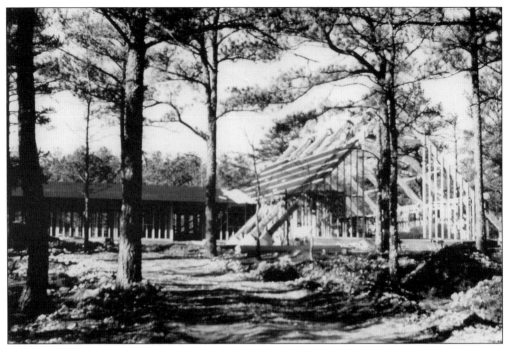

ST. ALBAN'S EPISCOPAL CHURCH. Bishop George Murray purchased 2.3 acres of land in the Bluff Park area in 1960. Several Episcopalians who supported an idea for a church in Bluff Park met at the community center in 1961. After canvassing the neighborhood to determine interest and support, they found a need existed, so they applied for a charter. Bishop Murray suggested St. Albans as the name, and it was approved. Prayer groups met at a house next to Bluff Park Elementary School in March. In September, services were moved to the elementary school's cafeteria. In October 1961, ground-breaking ceremonies were held and Bishop Murray, pictured below, broke the first patch of earth, starting the church's tradition in Bluff Park. The completed church building was dedicated on March 17, 1963. The first vicar was Rev. Charles Horn. (St. Alban's Episcopal Church.)

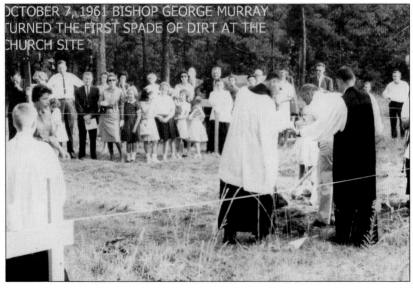

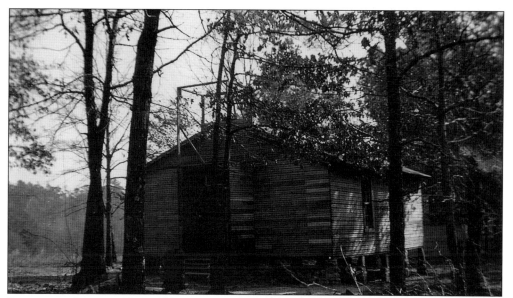

BEFORE THE CHURCH. Pictured here on a wooded lot on Cloudland Drive is a log cabin that once stood where St. Alban's Episcopal Church now makes its home. Previous owners of the property were the Joseph R. McDavid family, who sold it to the Drexel Hills Land Company. (Birmingham, Ala. Public Library Archives, File # 39-9-121.)

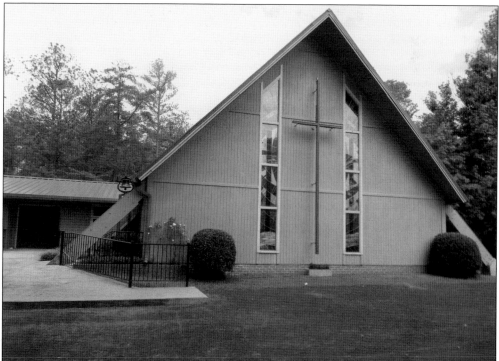

ST. ALBAN'S TODAY. One of the strengths of the church is its interaction with the community on a personal level. In 1998, St. Alban's opened its first Memorial Garden, which is used for reflection and for services like the Stations of the Cross in Holy Week. Unique to Bluff Park is the church's Pet Memorial Garden. (BluffParkAL.org.)

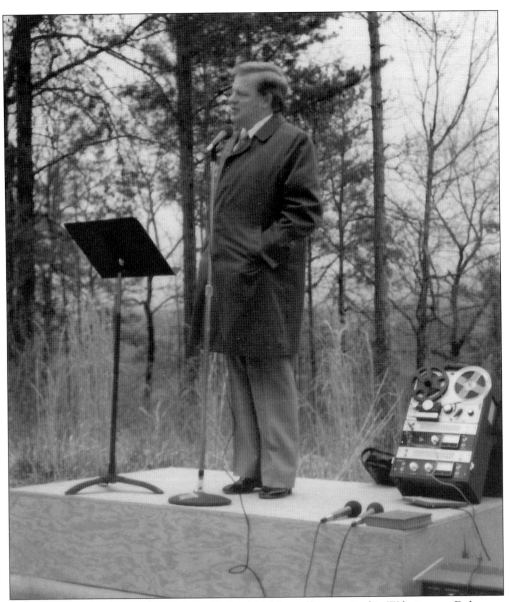

A BANKER WITH A HIGHER CALLING. Dr. Richard H. Vigneulle was raised in Wilmington, Delaware, and later graduated from Bob Jones University in 1953. Vigneulle was awarded an honorary doctor of divinity degree by the directors of Liberty Baptist Seminary. After college Vigneulle entered into business, and in 1970, he became the executive vice president of City Federal Savings and Loan. In 1969, a group started gathering in an open office area in a local insurance building to hear the banker share his testimony. He agreed to preach eight weeks of sermons only, but later agreed to stay on as pastor. In 1970, Vigneulle was ordained and the small church continued to grow. The 67 charter members formed Shades Mountain Methodist Church (Independent) on July 5, 1970. The banker-preacher continued as a lay pastor for several years until the church had grown to around 300 members. There was a need for full-time leadership, and Vigneulle took the job. (Shades Mountain Independent Church.)

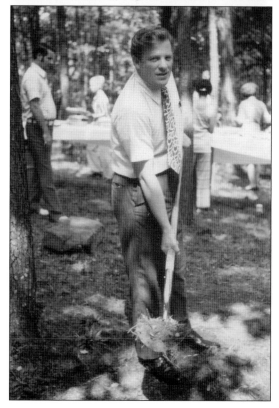

THE SITE AND GROUND-BREAKING. At the time, the leaders of the church were looking for a site to build upon, and one area on Tyler Road got their attention. The property, owned by US Steel, was not for sale but was a perfect location for the church. The church stepped out on faith and submitted a bid. Contract accepted! Pictured at right is founding pastor Dick Vigneulle at the ground-breaking event on September 19, 1971. Leroy Clark and Pastor Vigneulle came up with and implemented a bond program to raise money for the construction. The congregation bought and sold bonds and in 10 days, they were sold out. Architect Buddy Elliott designed Shades Mountain Independent to the vision of Pastor Vigneulle. He wanted something different from other churches in the area. The design chosen was a big barn style with a friendly, "come on in" feel. The original sanctuary was completed in 1972. Instead of stained glass, the huge windows of the sanctuary were clear and stretched from the floor to the ceiling. (Shades Mountain Independent Church.)

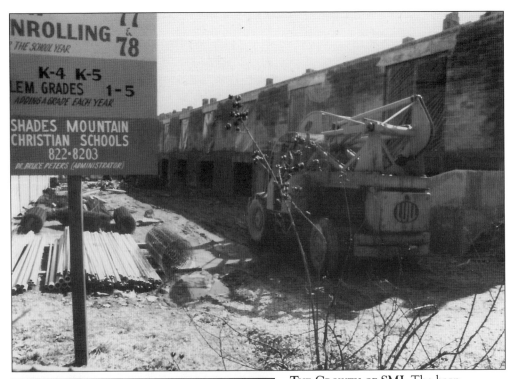

The Growth of SMI. The barn style became the pattern for all future buildings added on the campus of Shades Mountain Independent Church (SMI). In 1976, an additional building was added to accommodate a nursery and more office spaces, followed by an annex building for Shades Mountain Christian School and more Sunday school classes. In the 1980s, the sanctuary underwent expansion and a family life center was added, which is now the site of the Shades Mountain Christian High School. The school serves K3 through 12th grade and was founded in 1974. The school provides a strong academic program with a Biblical world view. Shades Mountain Christian School is also a class 1A program in the Alabama High School Athletic Association. (Shades Mountain Independent Church.)

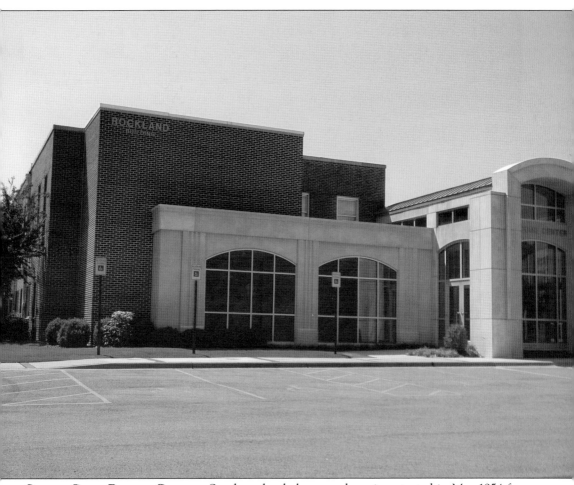

SHADES CREST BAPTIST CHURCH. Sunday school classes and services started in May 1954 for Shades Crest Baptist Church and were held in the Bluff Park School cafeteria. Wednesday night fellowship and potluck dinners were held at members' homes around the community. The congregation continued to meet at the school while searching for a building of its own. They turned the school into a church on Sundays, bringing their own supplies each week. Around the third month of the church's existence, its first pastor, Rev. John Norman of Fairfield, was called to head the church. The next year, the church was given property on Park Avenue owned by South Side Baptist Church. Seeing that Shades Crest had hired a pastor, continued to grow in the community, and was actively searching for property, the Southside Missions Committee decided to present the deed to its property on Park Avenue to Shades Crest Baptist. Ground-breaking for the Rockland Building began in March 1955. (BluffParkAL.org.)

FUTURE SITE OF SHADES CREST BAPTIST CHURCH. These two historic photographs show the land before the church started to build its first building in Bluff Park. The property on Park Avenue was owned by the Independent Presbyterian Church (future builders of the Fresh Air Farm in Bluff Park) and was later sold to Southside Baptist church. Southside Baptist held the land for possible church planting. Pictured above is an old log cabin set between the trees and facing the dirt road. Pictured below is an old tractor as it clears land on the site around 1939. (Shades Crest Baptist Church.)

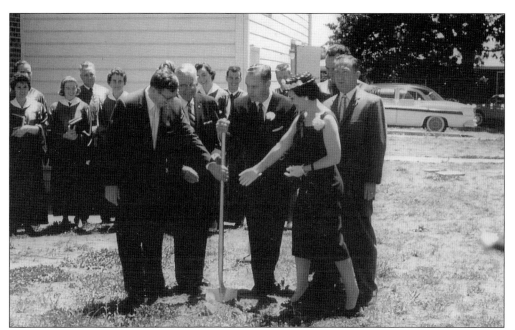

The Rockland Extension. In 1959, plans for the church's second building got underway. Pictured here at the groundbreaking of the Rockland Extension building, all with hands on the shovel, are Lucille Bagwell, Biff Vanderford, W.T. King, Rev. John Norman, Whit Millsap, and J.T. Weldon. (Shades Crest Baptist Church.)

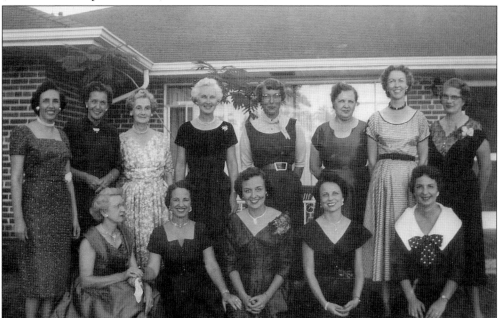

Pastorium Dedication. Pictured here at a dedication for the church's first pastorium are, from left to right, (first row) hostesses Margaret Parks, Tera Dell Millsap, Ann Norman, Elizabeth Carpenter, and Dodie Alvis; (second row) Bobbie Handy, unidentified, Marian King, Edith Thompson, Nina Bailey, Virginia Brooks, Billie Ruth Harrison, and Marian Cognum. (Shades Crest Baptist Church.)

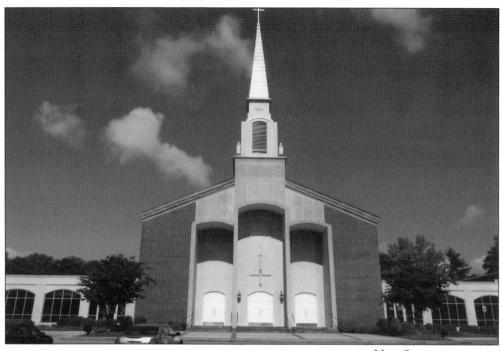

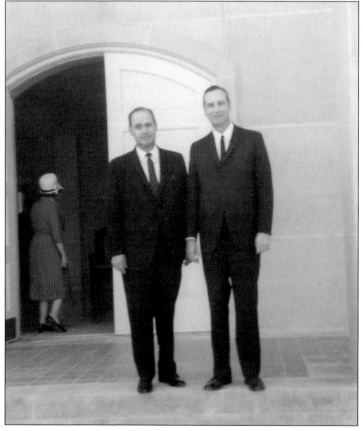

New Sanctuary and Second Pastor. In 1967, Shades Crest Baptist Church dedicated its new sanctuary on April 2. The sanctuary accommodates up to 900 people on the main floor and up to 350 people in the balcony. The exterior is brick and limestone with tall windows reaching the ceiling. Resting atop the steeple is a cross; the total height is about 120 feet from the ground to the top of the cross. Pictured at left, standing at the doors of the new sanctuary, are Rev. John Norman and Shades Crest Baptist's second pastor, Joe Parker, who was called as pastor in May 1965. (Shades Crest Baptist Church.)

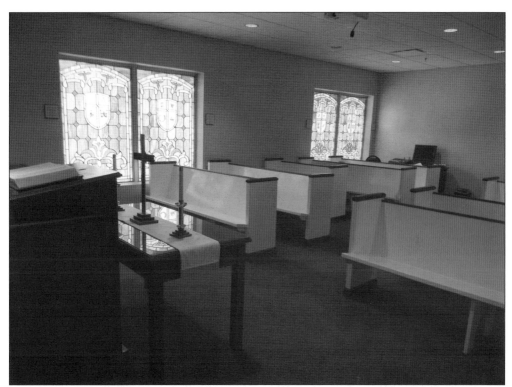

ANNIVERSARY AND ARTS. Shades Crest Baptist Church celebrated its golden jubilee in 2004. The church is now pastored by Rev. Denis Tanner and Rev. Terry Taylor. Preschool and children's ministries are headed by Rev. Shirley Gross, and Rev. Mark Johnson leads congregational life ministries. The church has a small chapel that simulcasts the Sunday service from the main sanctuary. In the chapel are pews built by the charter members who used them in the first years of the church more than 50 years ago. Shades Crest Baptist also has a school of the arts on its campus. The school offers instruction in voice, guitar, visual arts, violin, and piano for children and adults. It operates under the direction of Emily Logan. (BluffParkAL.org.)

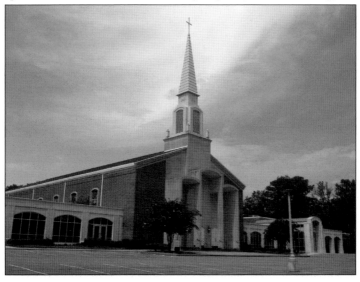

A New Addition to Faith in the Community. St. Luke's Korean Catholic Church now stands on the grounds where Summit Church and School got its start in the community. Located at the corner of Valley Street, Alford Avenue, and Tyler Road, St. Luke's is the first Korean Catholic church in the community. (BluffParkAL.org.)

Pioneer Play School. Bluff Park has a place for young kids as well. Not a run-of-the-mill day care, Pioneer Play School has been a starting point for the education of the youngest residents of Bluff Park since 1972. The day care was founded by Tom and Pat Lyle. (BluffParkAL.org.)

Six

THE PARK AVENUE
HISTORICAL DISTRICT

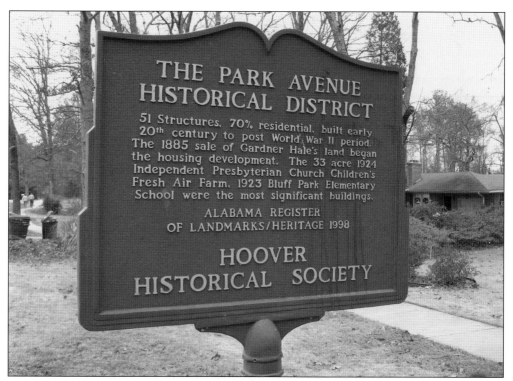

THE FIRST DISTRICT. Starting off the sections of historical districts in Bluff Park is Park Avenue. The historical districts and markers exist thanks to the hard work of Vadie Honea and the Hoover Historical Society. Park Avenue was listed in the Alabama Register of Landmarks and Heritage in 1998. Each marker gives a little history of its importance to Bluff Park. (BluffParkAL.org.)

THE OVERSEER'S HOME. This home is the oldest in the area at 120 years old. In 1889, A.B. Howell, a fruit broker from Chattanooga, Tennessee, built the home for the caretaker of his peach orchard. The first overseer of the property was William Winsley Morgan, who lived there with his wife, Eliza Hale Morgan, and their two sons. After the death of George Gardner Hale, his son William Marable Hale and his mother, Sophronia, who lived in Dadeville, Alabama, swapped homes with Morgan. The Morgans moved to the Hales' home and the Hale family moved into the overseer's home. William Marable Hale and his brother Evan Presley Hale were in charge of the Howell orchard operation until 1897. William Marable Hale, as overseer, managed the cultivation of trees and the shipping of fruit in season. As the Hale family started to grow, the need to move was evident. So Sophronia moved in with her brother-in-law Daniel Pratt Hale and then into homes built by the brothers. (BluffParkAL.org.)

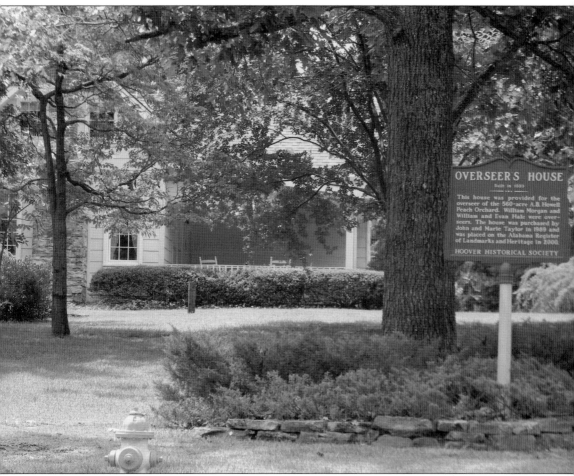

HISTORICAL OWNER. The home was owned by John McGraw and his descendants from 1906 until 1980. During that time, the overseer's house was expanded when the orchard property was sold off, and the house became strictly a residence. The roof was raised, and a kitchen and dining room were added. Indoor plumbing was installed sometime in the 1940s or 1950s. In the 1980s, the ceilings were lowered and an upstairs bedroom was added. A new wing consisting of a bedroom, bath, closets, hall, and carport was also added by current owner and Hoover Historical Society member Marie Taylor who bought the home in its 100th year. The original back porch of the home was converted into Taylor's General Store where she keeps her collection of vintage store items like coffee cans, spice cartons, canned goods, bottles, and signs. The overseer's home is also listed in the Alabama Register of Landmarks and Heritage. (BluffParkAL.org.)

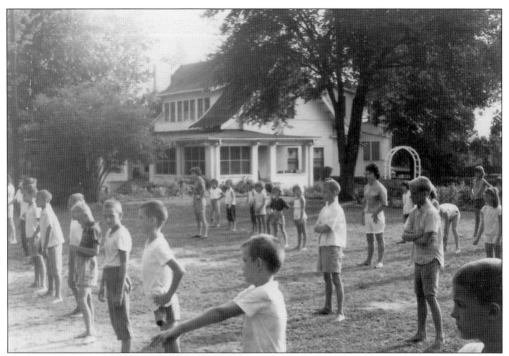

CAMP IN THE MOUNTAINS. The Fresh Air Farm is hidden behind the trees on Park Avenue. The private camp owned and operated by the Independent Presbyterian Church has been a home-away-from-home for young children for more than 80 years. In its beginning, it was an overnight camp for kids living in Birmingham whose parents worked in the smoky plants and factories downtown. (Fresh Air Farm Archives.)

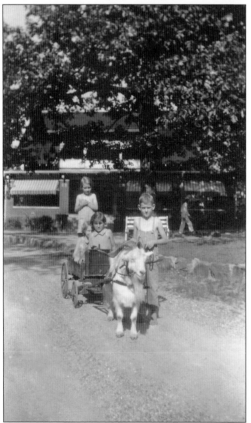

GOING FOR A RIDE, 1937. Pictured here attending camp at the Fresh Air Farm are a group of children being pulled by a goat and buggy. Because this was "country living" to city people, it was common for the children to get to see farm animals and get fresh milk. (Fresh Air Farm Archives.)

WATERMELON TIME, 1950s.
One of the goals of the farm
has been to offer fresh foods,
including fruit and milk. Here,
some children are enjoying
watermelon at the farm during
their summer camp. These kids
probably just came from the
swimming pool on the property.
(Fresh Air Farm Archives.)

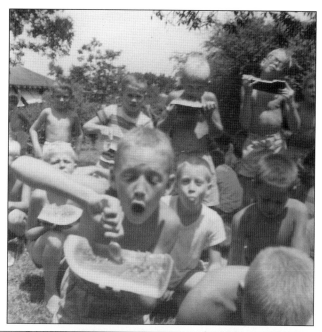

A CHANGE IN FOCUS. Population shifts in Birmingham changed the farm's focus. The farm started working more with inner-city kids, meeting health needs by offering dental clinics. In 2008, the camp changed again to an educational focus. The camp program features certified teachers and curriculums where kids between third and fifth grades continue schoolwork in the summer. Fresh Air Farm is directed by Gini Williams. (Fresh Air Farm Archives.)

STROLLING DOWN THE AVENUE. There are 51 structures on Park Avenue. The housing development of Park Avenue started after the sale of the Hale land and today is prime real estate in Bluff Park. Recently, sidewalks were added; they are popular for taking a stroll and for children to walk to school. This log cabin is one of the few left from the early years. (BluffParkAL.org.)

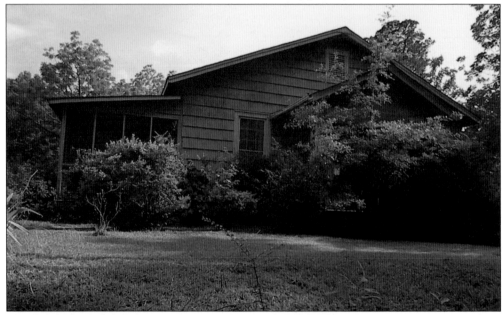

HALE'S MOVE TO PARK AVENUE, 1915. William and Bessie Hale sold their home on Bluff Road along with their sawmill, icehouse, and cotton gin to J.P. Wright and bought lots from brother George Jr. on Park Avenue. The lots were divided and given to each of the children. The Hales built on the corner lot of Crest Lane and Park Terrace at 2024 Crest Lane. (Greg Skaggs.)

HALE KIDS ON PARK AVENUE. The property at 538 Park Avenue was given to Emma S. Hale Dabney in 1922 as a wedding gift. The original home on the property burned down some time in the 1930s, and later, this home was rebuilt in its place. The house consists of four rooms with a large open porch. The Dabneys lived there until 1924. Eventually, the home was purchased by Pamela Nissen, a member of the Hoover Historical Society. In 1999, the society hosted its annual tea at the home. Seen below, another lot in the group is what is now 540 Park Avenue and was given to Hale's son Charles Henry Hale. (Greg Skaggs.)

ANNIE RUTH HALE HUTCHESON HOME. Annie Ruth Hale Hutcheson (1909–2009), the youngest child of William M. Hale and Bessie Hale, was the oldest-living member of the third generation Hale family at the time of her death. Hale was born in her father, William's, home at 633 Shades Crest Road before the family moved to 2136 Bluff Road, the Hale-Joseph Home. Ruth Hale and her husband, William Robert Hutcheson, lived at 2032 Crest Lane, shown here, which was property given to her by her father. The home was a central place for the Hale family, and Ruth's doors were always open. There were always cousins over to play cards and have snacks, which she always stocked to their personal tastes. The family photograph of Ruth Hale Hutcheson below is from June 2006. (Greg Skaggs and Bess Hale Hatcher.)

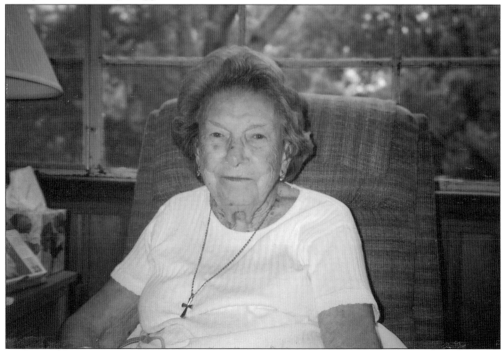

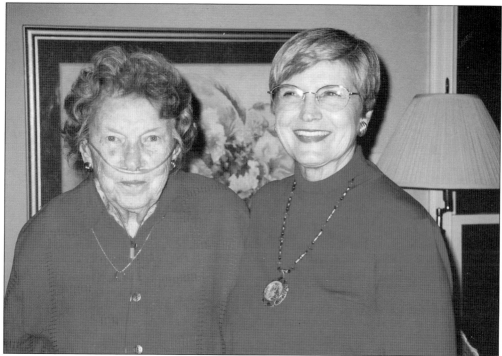

A Special Story of Family Love. Ruth Hale Hutcheson's daughter Bess Hale Hatcher is actually her niece. Ruth's brother Oswald Beale Hale (1907–1981) and his wife are the birth parents of Bess. Her natural mother died not long after her birth. Ruth took in her brother's daughter (Bess) as her own, and they always lived as mother and daughter. Pictured in December 2003 are Ruth Hale Hutcheson (left) and Bess Hale Hatcher (right). Bess Hale Hatcher still lives in Bluff Park today on the bluffs of Shades Crest Road with her husband and son. The Hatchers have a wonderful view from their back porch, looking over the bluff. As seen below, looking off in the distance from their back porch is Ross Bridge Resort and golf community. (Bess Hale Hatcher.)

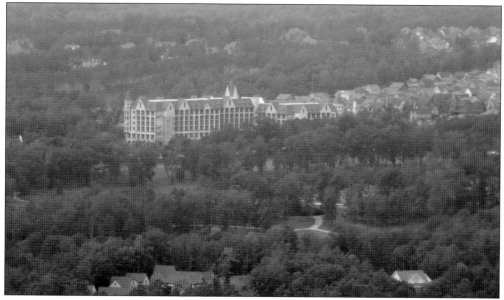

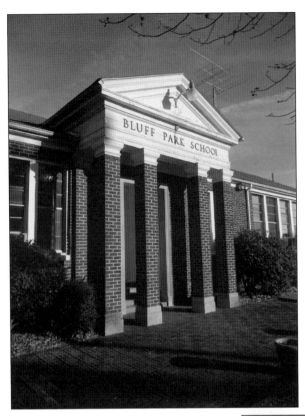

BLUFF PARK SCHOOL. The one-room schoolhouse known as Summit School evolved into Bluff Park School around 1923 or 1924 when the school moved to its current site on Park Avenue. At this time, there were a total of 50 students attending the school, much fewer than today. Also, there were not many teachers to go around at that time. Pearl Cranford and Ethel Hale taught the first classes at this location. In 1988, the school expanded from two classrooms to thirty-two. Pictured below, the old school bell and clock still hangs on the wall in the office and still rings its very loud bells. (BluffParkAL.org.)

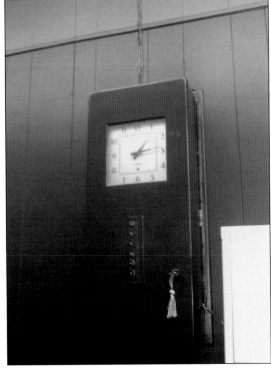

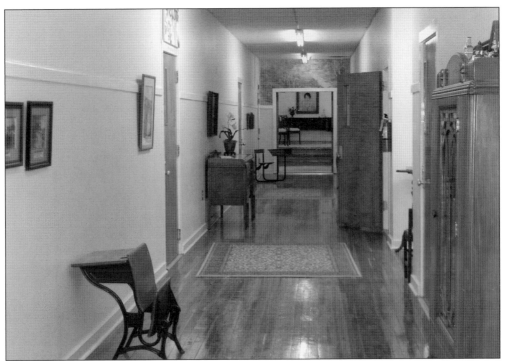

BLUFF PARK SCHOOL HALLWAY, 2009. Pictured above is the Bluff Park School as seen from the inside of the school's main hallway with classrooms to the right and left. The floor is the original hardwood left from the school's early years. The floors were refinished a few years ago. Hanging on the walls are historical photographs of the old school, and at the end of the hallway is the entrance to the Soon-Bok-Sellers Art Gallery, named after the local artist and teacher. Below is an old wooden desk on display in the hallway as an example of the early-period furnishings of the school. This old-style desk is small and not very comfortable. The classrooms would have been full of desks and children as the school day started. (BluffParkAL.org.)

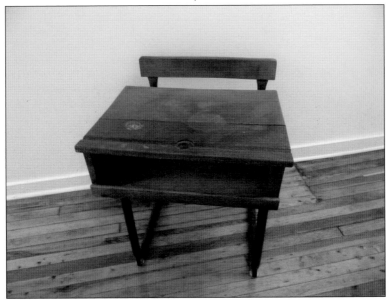

BLUFF PARK ELEMENTARY SCHOOL. In 1993, a new school was built next to the old Bluff Park School. The new school was called Bluff Park Elementary School and opened in the fall of 1993. Today, the school is part of the Hoover City School System and holds approximately 655 students with a ratio of one teacher for every 15 students. Shown below, outside the classroom walls students have a large playground and a gazebo for recreation. Also on campus is the Hoover Historical Society Folklore Center to help children and adults learn about Alabama history and the lifestyles of early settlers in the South. The educational setting is primarily Alabama in the 1840s. (BluffParkAL.org.)

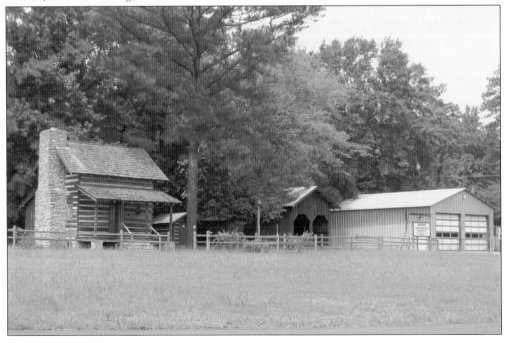

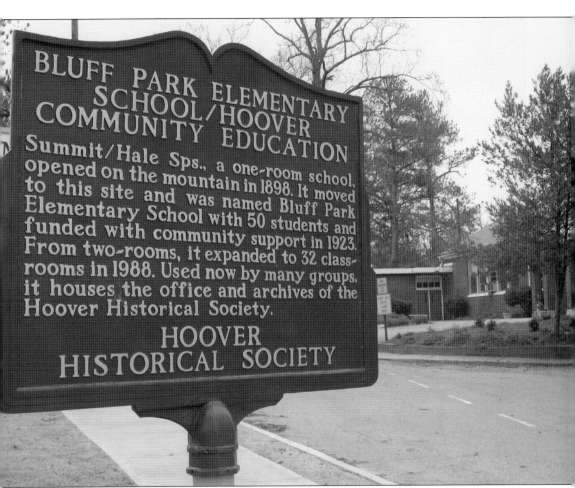

BLUFF PARK ELEMENTARY SCHOOL/HOOVER COMMUNITY EDUCATION

Summit/Hale Sps., a one-room school, opened on the mountain in 1898. It moved to this site and was named Bluff Park Elementary School with 50 students and funded with community support in 1923. From two-rooms, it expanded to 32 class-rooms in 1988. Used now by many groups, it houses the office and archives of the Hoover Historical Society.

HOOVER HISTORICAL SOCIETY

COMMUNITY EDUCATION. The old Bluff Park School building did not sit empty after the students moved to their new building. Under the direction of Linda Williams, director of community education, the old school became a community education facility for Bluff Park and later the city of Hoover. Williams's belief that education did not stop when the school bell rang opened doors for adults to take classes. One of the first classes offered at the facility was square-dancing because it was a group activity for senior citizens who had nowhere else to go at the time. Classes expanded to interior design, flower arranging, computers, and finance planning. At one point, there were as many as 60 classes in the system—everything from art to GEDs. The Hoover Historical Society also has its offices and archives in the historic school. Community education closed down for a short time, but a new plan was in the works for the facility. (BluffParkAL.org.)

BLUFF PARK ELEMENTARY OUTDOOR CLASSROOM. Bluff Park also takes its classrooms outdoors to teach science and nature. In 2009, work on Bluff Park Elementary School EcoScape won certification from the Alabama Wildlife Federation. The one-acre natural classroom sits on property adjacent to the school across a brick path that leads to the entrance at an arbor gateway. Ground-breaking for the outdoor classroom was on Arbor Day with the planting of two trees in memory of Ryan Winslow, a former student who died while serving in Iraq. There is a small creek running through the area, and there are also several learning stations where the children learn about weather, native plants and animals, and water systems. The facility includes a greenhouse and beds for the planting of flowers and vegetables. (BluffParkAL.org)

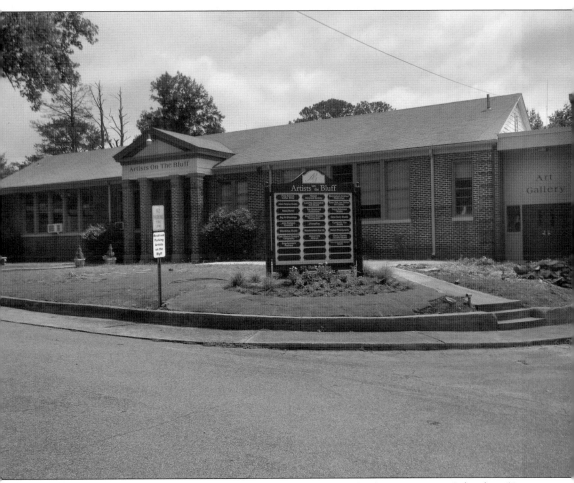

A New Purpose: Artists on the Bluff. In June 2011, Bluff Park Community School at 571 Park Avenue was officially changed to Artists on the Bluff, an Alabama non-profit arts education corporation. The project was a joint venture between the City of Hoover, Hoover City Schools advisor Linda Williams, and the Artists on the Bluff planning committee. The historic school had to undergo extensive changes to the building and grounds. The cafeteria was stripped and cleaned to make way for a coffeeshop, the hallways were repainted with a textured finish, and artistic lighting was added. The Soon-Bok Sellers Art Gallery was enhanced. Each of the old classrooms were turned into art and teaching studios by area artists renting the spaces. The grounds and landscaping were updated by removing many trees, planting flower beds, and putting a new coat of paint on the building. Gilded lettering replaced the old school sign. (BluffParkAL.org.)

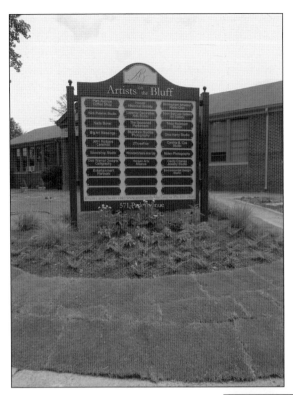

NEW OCCUPANTS. As new landscaping went in at Artists on the Bluff, a new sign was erected displaying each of the artists calling Bluff Park home. There are 22 studios, four teaching studios, two galleries, and an auditorium. Several forms of art studios at the facility include painting, woodworking, photography, Zentangle art, jewelry, sculpture, pottery, and calligraphy. (BluffParkAL.org.)

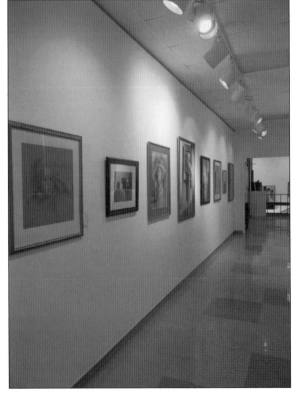

ART SHOW. The hallways of Artists on the Bluff are now lined with paintings and the displays of local artists as well as visiting collections for the Soon-Bok Sellers Art Gallery. Recent shows include "Works in Clay" and "The Alabama Pastel Society." Groups making their home at Artists on the Bluff are The Seasoned Performers drama group, 2 Three Five Motion Picture Co., Entertainment Partners, and Learning to be the Light. (BluffParkAL.org.)

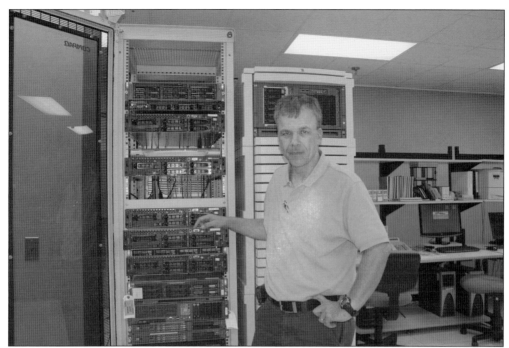

LEARNING TO BE THE LIGHT. LTBTL began in August 2011 to bring awareness to the issue of low-income families in the city of Hoover who had little to no computer or Internet access at home for schoolwork. Robin Schultz of PC Medics, pictured above, along with company intern Olivia Lenamond, below, came up with the idea as a way to give back to the community. LTBTL refurbishes donated computers and prepares them for modern use. Schultz and Lenamond wipe the PCs clean, re-install operating systems and freeware programs, then deliver and install the PCs for students in need. Names of low-income families are provided by Hoover City Schools. The name comes from a song by the group Newworldson and is based on Bible verse Matthew 5:16. (Learning To Be The Light.)

ARTISTS POSE. Pictured at Artists on the Bluff are just a few of the artists at the facility. From left to right are Barbara Sloan of The Seasoned Performers; jewelry and metalwork artist Cecily Chaney; clay and sculpture artist John Rodgers; and artist and director of Artists on the Bluff Rik Lazenby. (BluffParkAL.org.)

BOARD MEMBERS. Artists on the Bluff is governed by a board of directors consisting of community members, artists, and advisors. Original board members pictured here from left to right are Linda Williams, Belle Jordan, and director Rik Lazenby. Not pictured are Ron Jones, Barbara Sims, and Heather Skaggs. (BluffParkAL.org.)

Seven

THE SHADES CREST HISTORICAL DISTRICT

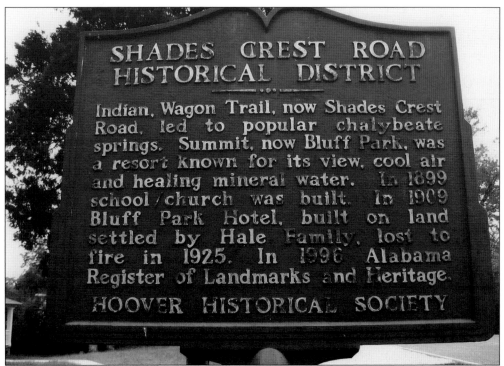

HISTORICAL ROAD. Shades Crest Road, in its days as a wagon trail and dirt road, was the main access to the mountain resort of Hale Springs/Bluff Park. Liberty Hall, Pinnacle House, and the Bluff Park Hotel all stood on what is now Shades Crest Road. The district was established by the Hoover Historical Society and placed in the Alabama Register of Landmarks and Heritage in 1996. (BluffParkAL.org.)

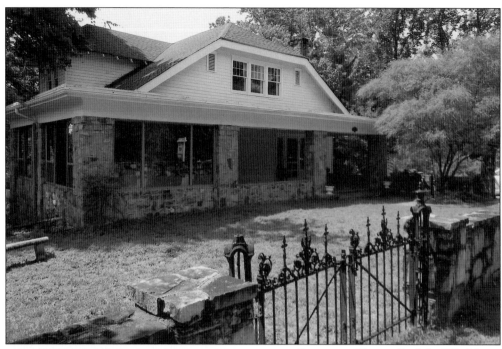

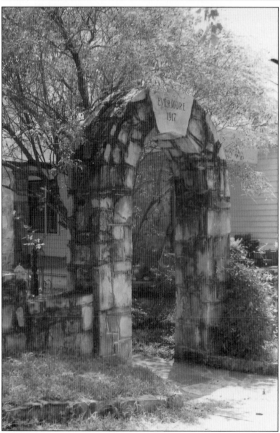

EVERMORE HOUSE. Built by T.L. Moses around 1917 or 1920, this home is located at 901 Shades Crest Road. It is made from heart pine wood brought in from Mississippi, and it has three levels and four fireplaces. Mrs. Moses had a lush and flowering garden. At some point, an artist lived in the house and painted three beautiful murals in the parlor. There is also a well on the ground floor where spring water was brought up. The Shelby family and the Moses family put on a fireworks show from the rock formation at the home every Fourth of July. The Klassen family of Klassen Florist in Birmingham bought the home in 1972. The house has recently been for sale once again. (BluffParkAL.org.)

WHEELER HOME, 972 SHADES CREST ROAD. Built around 1928, this was the residence of Judge Robert J. and Mary Wheeler. Judge Wheeler was a longtime judge in Birmingham, and Mary Wheeler was a member of the Shades Crest Garden Club. In 2002, the home was listed in the Alabama Register of Landmarks and Heritage. (BluffParkAL.org.)

THE L.C. STEWART HOME, 976 SHADES CREST. Also listed with The Jefferson County Historical Commission is this home listed in 2007. It was built in 1950 by T.E. Bonner and owned by Elise W. and L.C. Stewart from December 1950 to April 2000. The screen porch was enclosed between 1953–1960 and the home still has the original cedar planks installed. (BluffParkAL.org.)

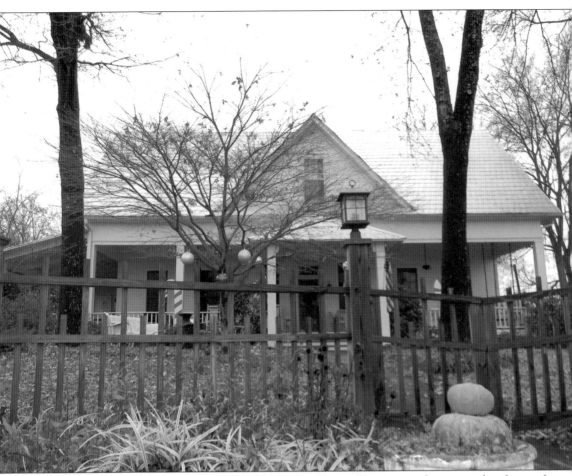

THE A.C. SHARPLEY HOME, 675 SHADES CREST ROAD. Here is another example of one of the larger homes on the bluff. The style allows for maximum benefit of mountain breezes and beautiful views thanks to the wraparound porches perfect for rocking chairs. This home was built around 1905 and has five fireplaces for heating the home on cold mountain nights. A.C. Sharpley, listed as one of the builders, bought the property in 1902 from Daniel P. Hale. Sharpley is mentioned in the *Hale Springs Ledger* in an account where the Sharpleys hosted friends and guests visiting Hale Springs in August 1907 at their home before dinner was ready at the hotel. Sharpley was born in Lincolnshire, England, and moved to Birmingham, Alabama, in 1887. He later established a brick and building company named Robertson Brick Co. Later owners of the home include the Coghill family, the Frank Hewitt family, the Beasley family, and the Chambers family. (BluffParkAL.org.)

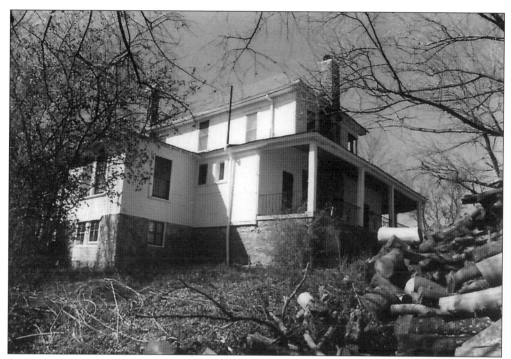

SITE OF DANIEL PRATT HALE'S HOME. This is the home as it stood in 1971, the way Daniel Pratt Hale built it. It is said that a barn on the property was used as one of the worship places for people on the mountain until services were moved to a brush arbor at the intersection not too far down the road. The last Hale family member to occupy the home was Allie W. Hale. At some point, the home partially burned down, leaving only the stonework behind. The home that now stands on 713 Shades Crest Road is on the property where Daniel Pratt Hale's home once stood. (Susan H.C. Kelley.)

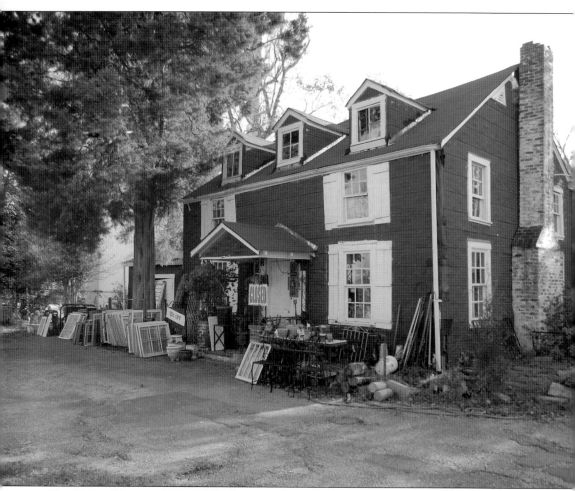

THE HOUSE MADE OF SCRAPS. The first recorded use of this property was for tennis courts for the Bluff Park Hotel. There were wooden sidewalks leading from the corner of what is now Shades Crest Road and Tyler Road across the land up to the hotel. In 1930, builder William Wyatt used salvaged materials pieced together to construct this home that still stands on the property. In the time of the Great Depression, lumber and building supplies were not readily available so Wyatt built the house from whatever he could find. The pine flooring was recycled from Hillman Hospital (University Hospital in Birmingham). The windows and doors differ in size, reflecting the lack of "standard" sizing at the time. The home stayed in the Wyatt family until William's widow sold it to Lee and Rodney Thursby in 1982. The Thursbys turned the home into an antique shop naming it "On A Shoe String." An old Nashville, Chattanooga & St. Louis Railway (NC&StL) bay window, wood-framed cab sits on the side of the house as part of the antique shop. (BluffParkAL.org.)

INSIDE THE ANTIQUE STORE. The name On A Shoe String was fitting for this home as it was a time when people were on a "shoe string" budget. After two months of repair work on the building, the shop opened in September 1982 selling everything from old car tags to crystal. The home still holds its original vintage look. (BluffParkAL.org.)

LEE AND RODNEY THURSBY. Pictured here are the Thursbys inside their antique shop On a Shoe String in the Shades Crest Historic District. The shop has been open for more than 30 years and the Thursbys do not plan on closing anytime soon. (BluffParkAL.org.)

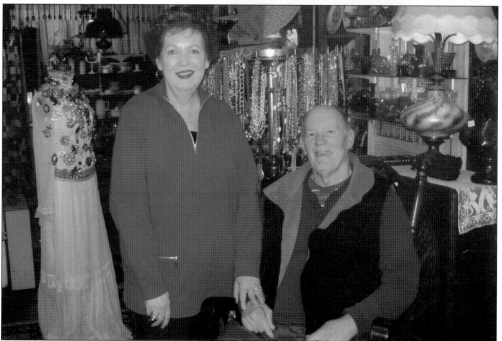

LOVER'S LEAP. These large limestone boulders jut out over the valley and hold inscriptions from couples, friends, and lovers. One of Alabama's first legislators, Thomas W. Farrar, came to the area and camped for several days with his new bride on what he called Sunset Rock. He carved into the limestone the first four lines of "Childe Harold's Pilgrimage," a poem by Lord Byron: "To sit on the rocks, to muse o'er flood an fell, to slowly trace the forest's shady scene where things that own not man's dominion dwell, and mortal foot hath ne'er or rarely been." Farrar later founded and served as grand master of the first Masonic lodge in Alabama. In the early 1930s, the original inscribed rock was removed and presented to the Masonic lodge in Elyton, named after Farrar. (BluffParkAL.org.)

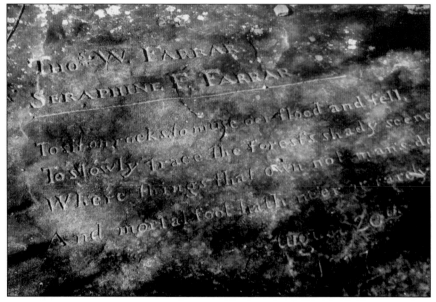

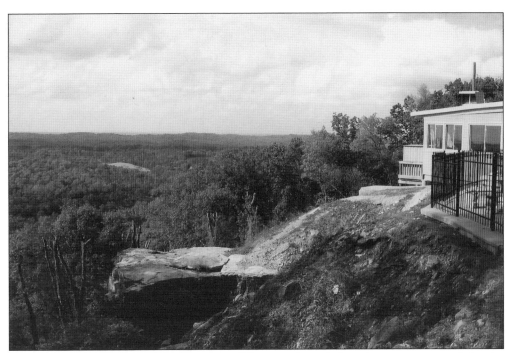

INDIAN LEGEND AND PERSONAL CARVINGS. There is a legend that also centers around the site of Lover's Leap. The old Creek Indian legend tells of a brave who, tired of the love of a tribal princess, stabbed her on the rock and then jumped with her in his arms out of regret for killing her. In 1935, the site was donated to the public. Residents Thomas W. Martin and George B. Ward gave a replica of the Farrar carving to the site, which is now protected by a wrought-iron fence. In 2001, the area was revitalized and now visitors can take a picnic and walk right on the historical site by the Tip Top Grill to add their own carving among the many from years past. (BluffParkAL.org.)

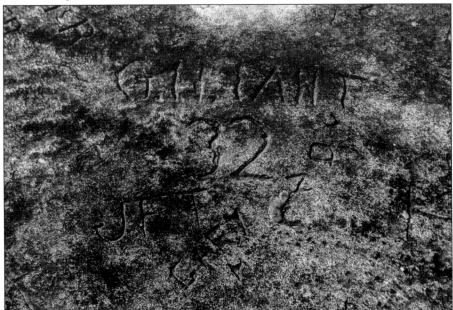

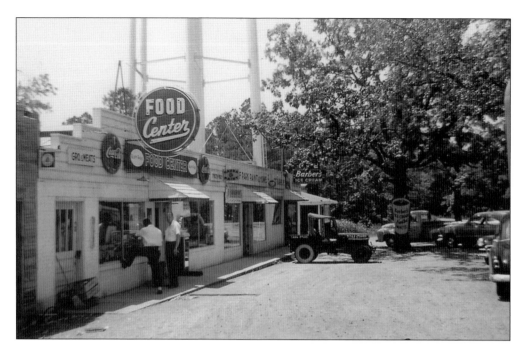

SHOPPING IN BLUFF PARK, 1950S. There are two shopping centers along Shades Crest Road in Bluff Park. This section, photographed in 1954, shows the old Food Center, Bluff Park Paint Shop, and Barber's Ice Cream Shop under the water tower. Note that the parking lot is not paved but is dirt. Below, to the left of the Food Center is the Gulf Gas Station with an attendant standing ready at the pumps. Self-service was not found here. Motorists still got drive-up service to "filler up" on the mountain. (Birmingham, Ala. Public Library Archives, Files 39-4-4-5-2E and 39-4-4-5-2D.)

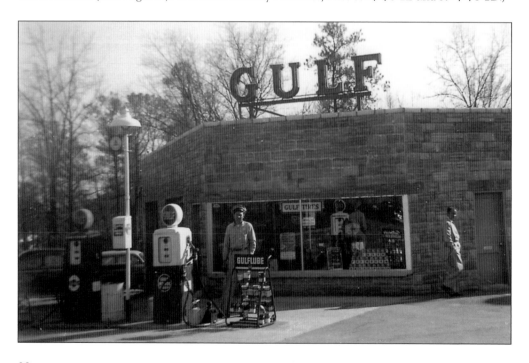

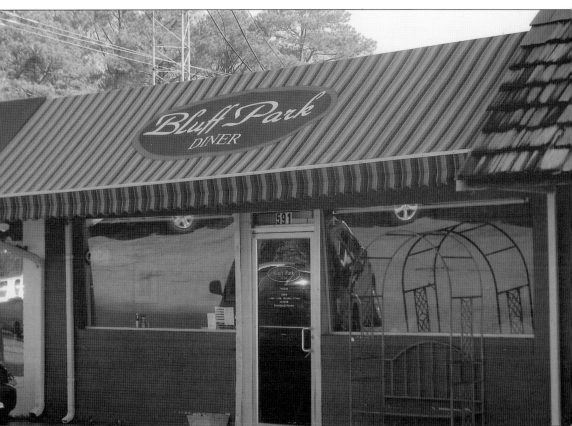

BERT'S ON THE BLUFF/THE BLUFF PARK DINER. Bert's on the Bluff, named after owner Bert Roberts, was a cafeteria-style diner that was a staple in the community for many years. At times, there were lines going out the door just to get a table for dinner. Hungry patrons enjoyed Southern cooking like fried chicken, okra, and corn on the cob. Bert's closed in 2006, leaving the community very sad. A year later, Bob Hoeferlin, owner of the Tip Top Grill across the street, bought the place from Roberts's son Doug and reopened it under the new name Bluff Park Diner. The eatery had a new name and a new menu but the same great appeal to the community. The diner kept the cafeteria-style setting the customers liked, and the menu expanded to include meatloaf, pot roast, lasagna, turkey and dressing, and fried or baked fish—and do not forget the choice of cornbread or roll. (BluffParkAL.org.)

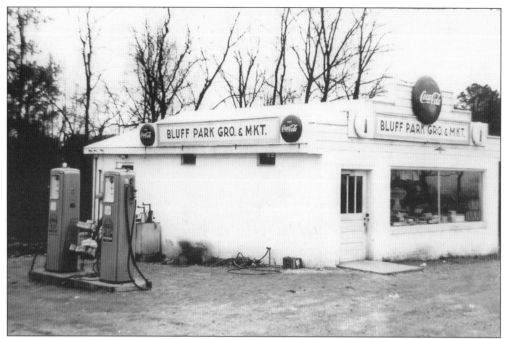

BLUFF PARK GROCERY MARKET AND SANDWICH SHOP. These two photographs show the Bluff Park Grocery and Market from 1949 and the Bluff Park Sandwich Shop from 1951 on Shades Crest Road. They are examples of long-gone businesses on the bluff. At the Bluff Park Grocery and Market shop, people could also buy gasoline. Note the vintage Coca-Cola signs. At the Bluff Park Sandwich Shop, locals could pick up a fresh sandwich and a malt. See the smoke from the roof? Looks like the cooks were ready for the day! (Birmingham, Ala. Public Library Archives, File # 39-4-4-5-2A and B.)

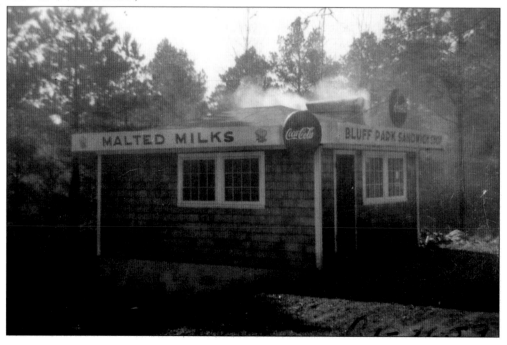

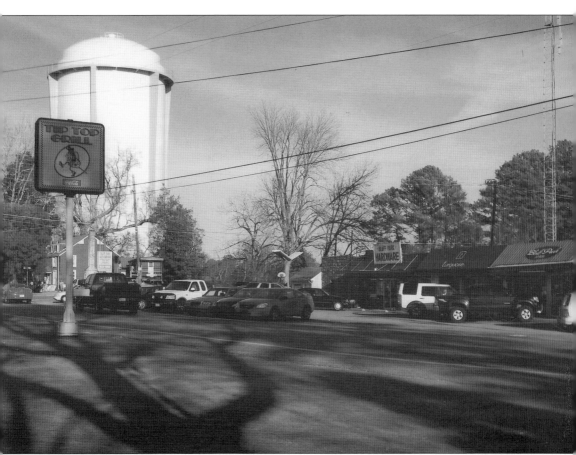

Shopping With a View of the Bluff, 2010. After a suspicious fire in 1998, this complex was restored. Currently, the Bluff Park Shopping Center is home to Bluff Park Hardware and Bluff Park Auto—both of which are longtime institutions in the community, Moonlight on the Mountain concert hall, the Bluff Park Diner, Turquoise (a clothing shop), Bluff Park Barber Shop, and other offices including, Hale Springs Financial Group, Alabama Justice Ministry Network, Artistic Concrete Concepts, Leading Edge, and Hope Manifest. In the background on the left under the water tower is On A Shoe String Antiques and across the street on the bluff side is the Tip Top Grill. This has always been a busy intersection of Bluff Park whether it is a day filled with shopping, eating, grooming, enjoying a concert, or watching the sunset from Lover's Leap. (BluffParkAL.org.)

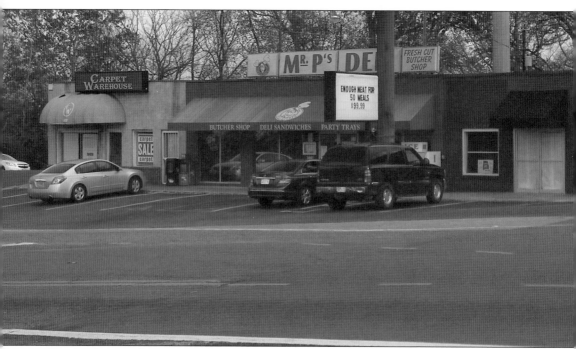

THE MCALISTER (MCALLISTER) PROPERTIES. At the intersection of Shades Crest Road, West Oxmoor, and Tyler Road is the property knows as McAlister's Shopping Center. The brush arbor church that was the site for worship services for people on the mountain once stood here. In 1906, Jack Williams, who was an active member of the community and Summit Baptist Church, bought the property and opened a general store. In 1926, V.C. McAlister bought it and the store changed to "Mac's store." McAlister added a post office and telegraph station before he died. Today, the intersection is home to Mr. P's Deli, Carpet Warehouse, Pinnacle Education Services, Bluff Park TV Repair, Pizazz Hair Salon, Crandall CPA, Cockrell and Associates, and the Laura Crandall Brown Ovarian Cancer Foundation. Across the street are John's Auto, Bluff Park Masonic Lodge, Future Trend 2000 hair salon, and the Birmingham Music Club. In 2011, the road was widened, a new traffic light was added, and a "Welcome to Hoover" sign was put up. (BluffParkAL.org.)

NEWER BUT STILL HISTORIC HOMES. These two homes built in 1949 and 1950 are slightly outside the original historic district but are still located on Shades Crest Road. Above, the Ellithorpe-Wade house, built in 1949 by Mr. And Mrs. Ellithorpe, is a Cape Cod–style home with seven rooms located at 313 Shades Crest Road on the old Crest Road. The home was listed with the Jefferson County Historical Commission in 2008. Below, the Northrup-McClellan house was built in 1950. The first long-term residents of record were H.G. and Mildred McClellan when they bought it from the Northrups in 1955. The McClellan family lived there until 1992. The home was listed with the Jefferson County Historical Commission in 2005. The Northrup-McClellan House is located at 425 Shades Crest Road. (BluffParkAL.org.)

THE DISON FAMILY AND BLUFF PARK. This section of Shades Crest Road was part of the acreage bought by Nathan Dison in 1885. Dison and his wife donated land where the original Summit–Bluff Park School stood on what is now the intersection of Valley Street and Alford Avenue. The Dison family members were active in the churches and school in Bluff Park and are listed among the 23 charter members of Bluff Park Baptist Church. One of the Dison granddaughters married Jack Williams, who was the owner of Williams Store. The home in the foreground, located at 873 Shades Crest Road, sits on the land once owned by the Dison family. Some of the past owners of this lot, dating back to 1936 and possibly earlier, include the Whittle family, the A.S. and Nona D. Crowley family, and the J.C. and Nora Miller Family. Equalization files indicate there was also a chicken house on the property at one time. (BluffParkAL.org.)

Eight

THE COMMUNITY

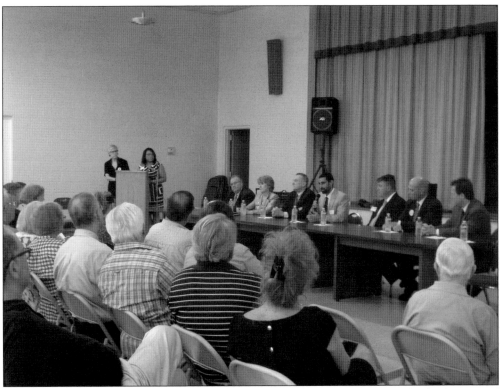

COMMUNITY INVOLVEMENT. Bluff Park is a close-knit and active community. It also has one of the highest voter turnout rates in the city of Hoover. Residents here listen as candidates answer questions at a Hoover City Council candidate forum held at the Artists on the Bluff auditorium, hosted by the League of Women Voters and BluffParkAL.org. (BluffParkAL.org.)

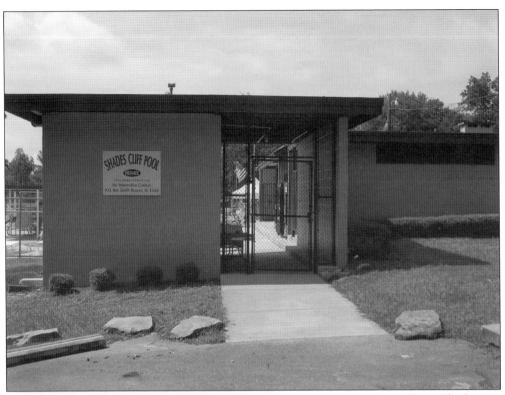

SWIMMING IN BLUFF PARK. Shades Cliff Pool was an idea hatched from several community members who thought this land would be perfect for a community pool. With the heat in the South, a pool would certainly get good use. The private pool was built during the winter of 1963–1964 and opened in the summer of 1964. The facility has one large *L*-shaped pool with a 25-meter competition area and diving well and one small shallow pool for children and babies. There are also dressing rooms and bathrooms. Several deck expansions and additional bathrooms have been added over time. Each summer, the pool is filled with kids and adults trying to beat the Southern heat. (BluffParkAL.org.)

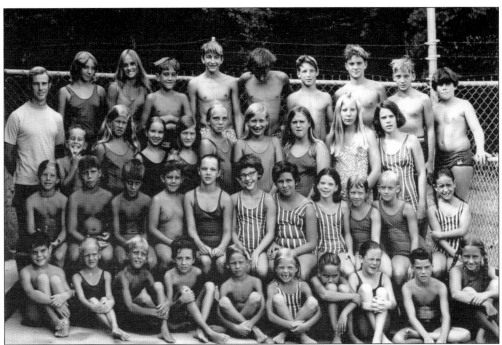

SWIM TEAM. Since its inception, Shades Cliff Pool has offered a competitive swim and dive team as well as swim lessons for its members. The teams have won numerous awards and ribbons throughout the years. This photograph from the 1970s is of the Shades Cliff Swim Team. Pictured below jumping into the diving well are lifeguards at the pool's Labor Day party in 2009. After putting all the chairs and supplies away, the guards celebrated by taking a funny action shot to close the holiday celebration. (Above, courtesy of swim team member Lynn Johnson Smith; below, courtesy of lifeguard Joy Waldrop.)

COMMUNITY CENTER. The community center and park area on Cloudland Drive next to Shades Cliff Pool is a place for events, meetings, and weekend activities. The community center can be rented out for family reunions, birthday or holiday parties, rehearsal dinners, and retirement functions, just to name a few. The meeting hall accommodates as many as 60 people and has bathrooms and a kitchen. The center is on three acres of land covered with shade trees and boulders. The park area includes a large playground with swings, a slide, and a climbing structure. There is also a wooden gazebo donated by the Bluff Park Art Association in honor of Al Tetley. Also on site is the Bluff Park Troop 21 Boy Scout hut and the Hoover Lions Club hut. (BluffParkAL.org.)

THE BEGINNINGS OF THE BLUFF PARK ART SHOW. In 1963, a group of parents from Bluff Park Elementary School sponsored a "Come As Your Favorite Book" dance as their first fundraising project in hopes of expanding the school library. Then, in 1964, an art auction was held and organized by most of the same group of parents and with the sponsorship of the Bluff Park PTA. Artists in the community contributed their paintings and crafts, and $850 was added to the library fund. In 1965, the group formed a nonprofit corporation and held a second art show. This show had 65 artists participating. The response and support of the Birmingham community was so great that the show has become the largest annual event held in the community. (BluffParkAL.org.)

THE BLUFF PARK ART SHOW. Organized by the Bluff Park Art Association and held for 47 years, this show has hosted many national talents from across the country. The show attracts more than 30,000 people each year. It is held on the first Saturday in October at the Bluff Park Community Center and Park off Cloudland Drive. These photographs from 2010 show everyone enjoying the many art booths at the show. There is everything from paintings, stained glass, ironwork, woodworking, jewelry, cloth, blown glass, and pottery. The top award given each year is a purchase award, and the winning work is added to the association's permanent collection. The collection of around 100 pieces of art is rotated and displayed in local schools, colleges, and other public buildings. (BluffParkAL.org.)

TREATS AT THE SHOW. The art at the show also comes in the form of good food! Several civic clubs set up and offer good eats varying from corn dogs and homemade sausage to popcorn or pizza. The United Methodist Women's Group from Bluff Park Methodist Church has a large bake sale at the show with all the homemade cookies and cakes a person could want. As seen below, the show is not just for humans; Bluff Park's four-legged residents also come along to join in the fun. Check out this guy hanging out with the crowd in 2009. It is common practice to bring the pooches down to the park to enjoy the Bluff Park Art Show. (BluffParkAL.org.)

DANCE CAPADES

Presented by

THE STUDENTS OF

FRANCES ARMSTRONG

and

GINA CROCKER

SATURDAY EVENING, MAY 21, 1988
7:30 P.M.

SHADES VALLEY HIGH SCHOOL
AUDITORIUM

FRANCES'S DANCE STUDIO/THE DANCE CENTER. A dance studio was opened by Frances Armstrong in her home at 645 Shades Crest Road, Sophronia Hale's old home. As the studio grew, teachers were added for ballet, tap, jazz, tumbling, and gymnastics. Some teachers joining with Armstrong were Tammy Price, Gina Crocker, and Patty Birchfield. Pictured here is a recital program from 1988. The school held its yearly recital at Shades Valley High School. Students also had the opportunity to perform at the annual Christmas party, held at the Bluff Park Community Center, and in other special performances for residents of area nursing homes. After Armstrong retired, the studio moved to a building on nearby Valley Street and the name was changed to "The Dance Center" under the direction of Tammy Price and Kristie Weaver. Armstrong passed away at the age of 94 in 2011. Many past students were in attendance at the funeral, including her surrogate family: Donny, Tammy, Christopher, and Corey Price. (Courtesy of the family of Helen and Perry Jones.)

RUNNING ON THE BLUFF. Shades Crest Baptist Church hosts the annual 5K run in Bluff Park. In its 11th year, the race is RRCA sanctioned and USATF certified and includes a one-mile "Fun Run" for kids. Starting at the church, it winds its way through the area. The course is monitored by the Hoover police for the morning of the race and time splits are given at each mile. Below, racers are pictured at the starting line at the third annual event. Awards go to the top male and female divisions and also to the top three in each age division. Locals line the streets to cheer their favorite runners and hand out drinks and snacks. Free breakfast is served at the church after the run. (BluffParkAL.org and Shades Crest Baptist Church.)

ALL FOR ONE COMMUNITY PARTY.
Seen above, the Hoover police Mobile
Command Unit was on display
at the 2008 community party for
residents to see. In 2007 and 2008,
BluffParkAL.org hosted community
appreciation parties open to all
residents. The party was also an
opportunity for Hoover police and
fire departments to interact with
the residents and demonstrate new
technology. At left, partygoers hang
out at Caribbean Shaved Ice at the
2008 community party held in the
Shades Mountain Shopping Center. It
was a very hot day and the shaved ice
was very popular. The social events
had venders, music, classic car displays,
inflatable jumps for kids, and booths
sponsored by area churches and other
organizations. (BluffParkAL.org.)

10 YEAR PARTY. Bluff Park likes to have parties. In August 2012, Robert's Discount Pharmacy, owned by Robert Mills, held a customer-appreciation party for the community in the parking lot of his store. Robert's celebrated its 10th year in Bluff Park by cooking hot dogs and hamburgers for the community. There was also live music and a "Dunk the Pharmacist" dunking booth! (BluffParkAL.org.)

BREAKFAST ON THE GO. Another Bluff Park event hosted by Shades Crest Baptist Church, "We Love Hoover Day" features church members giving out breakfast to cars passing by on their way to work or to take kids to school. Pictured here, Allyson George hands out breakfast to the driver of a truck on Park Avenue. (Shades Crest Baptist Church.)

MORE SHOPPING. Pictured above, Shades Mountain Plaza at one point was pastureland with horses and cattle. Today, the square is made of two strip malls and four free-standing buildings. Shades Mountain Plaza features a Piggly Wiggly grocery store and a post office. Robert's Discount Pharmacy, Shades Mountain Cleaners, and Ashley Mac's gourmet foods and catering business make up the rest of the main complex. Also on the property are a dance studio, Merry Maids, and Carto Craft Maps. Seen below, another complex is just above the plaza. In Bluff Park Village, an Armor Safe Storage anchors the center. A Hoover city police substation, New China restaurant, Happy Tails Pet Grooming, and various other retail establishments round out the location. Two dentists' offices and a veterinarian's office are also in this area. (BluffParkAL.org.)

HALLOWEEN IN BLUFF PARK. Halloween is a big event in Bluff Park. Several streets close off for kids to go trick-or-treating and the churches host "trunk-or-treats" where kids can receive candy at cars in the parking lots. This car at Chapel in the Pines trunk-or-treat is packing candy and a television for kids to watch their favorite cartoons. Below, inflatables are on display in the Carisbrooke subdivision, which has a huge Halloween turnout. Many of the homes in the area decorate to the fullest. On Halloween night, kids fill the street from all over the community to trick-or-treat. One house even served snow cones! (BluffParkAL.org.)

TRICK-OR-TREAT TRAIL AND FALL FESTIVAL. Above, an "alien" is landing at the Trick-or-Treat Trail on Park Avenue. While these aliens may come in peace, this trail, winding through a side yard, is filled with creepy spiders, spooky witches, ghoulish pumpkins, and, at the end, Halloween candy for anyone daring to walk the trail. The trail is hosted by Rhonna and Jonathan Phillips with help from friends Phil Free, Bill Bowen, and many others. The trail has been an annual event since 1995. Below, kids at Bluff Park United Methodist Church's Fall Festival play "spinning pumpkin" at one of the carnival games at the church's annual Halloween event. Little super heroes, princesses, fairies, and spacemen come from all over the community to play games and trick or treat for Halloween in Bluff Park! (BluffParkAL.org.)

CHRISTMAS ON THE BLUFF. Christmas in Bluff Park is always a special time. Churches host choir concerts with Christmas carols, special candlelight services, and dinners. Boy Scout Troop 21 has an annual Christmas tree sale at Bluff Park Methodist Church offering any size and shape tree. Bluff Park Baptist presents a living nativity story performance and hayride through the neighborhoods to see Christmas lights. There are several streets where every home is decorated for the holiday. Here are two examples of Christmas light displays in Bluff Park from 2009. The nativity scene at this house is displayed every year without fail and is an eye-catcher. (BluffParkAL.org.)

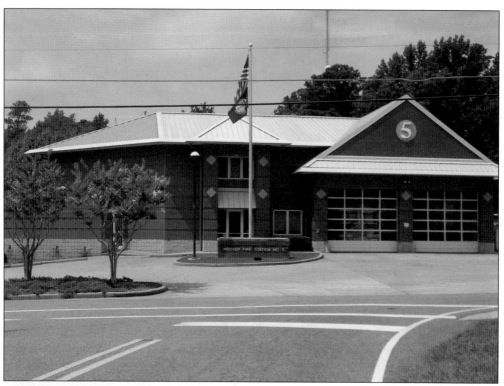

VOLUNTEER FIRE DEPARTMENT AND THE FIRE TOWER. The Bluff Park Fire District was well established when it was annexed into Hoover in 1985. At the time, it was the oldest fire district in the state of Alabama. Blake W. Jones is the current captain of Fire Station 5 and John C. Wingate serves as fire chief for Hoover. The Crawford fire tower (pictured at left) was built on Shades Crest Road to aid in spotting fires. In the 1990s, the tower was taken down and only the cab survived. The cab sat deteriorating over time until the Hoover Historical Society restored it. The fire tower cab was placed in front of Hoover Fire Station No. 2 near Simmons Middle School in August 2012. (BluffParkAL.org.)

HIDDEN JEWEL. Moss Rock Preserve is a 350-acre nature habitat in Bluff Park. The preserve is filled with rare plants, waterfalls, and wildlife. The Boulder Field within is a popular place for rock climbers. With nearly 12 miles of hiking paths, enthusiasts can experience the hidden beauty in Bluff Park. Groups like the Friends of Moss Rock Preserve and the area Boy Scout troops maintain the trails as well and perform other general maintenance. In 2003, the city of Hoover adopted an ordinance to aid in protecting the preserve. In May 2012, the city of Hoover added 99 acres of city-owned property to the Moss Rock Preserve. Pictured here, climbers Emma Krueger and Hudson White scale the side of a rock outcropping and enjoy a day in the Moss Rock Preserve in 2012. (Emma Krueger and Hudson White.)

EXTREME WEATHER IN BLUFF PARK. On April 27, 2011, Alabama was devastated after being hit by 63 tornados that tracked from Mississippi to Tuscaloosa, Alabama, through Birmingham, and then out of the state. The EF4 tornado that hit Tuscaloosa and Birmingham originated in Newton County, Mississippi. Earlier that same morning, Bluff Park was hit by a tornado from an earlier system of storms. Several roads, including two of the main roads through Bluff Park—Shades Crest Road and Park Avenue—were blocked by uprooted trees and downed power lines. Many homes suffered severe damage. It took several days to clear all the debris and return power to the area. Bluff Park Elementary on Park Avenue had to suspend classes until the following week due to power damage. (BluffParkAL.org.)

BLUFF PARK CEMETERY. In closing this journey through Bluff Park, it is important to know where its residents came from. This mountain that so many call home was home to only a few at first, but it is now a thriving community that values its peaceful solitude while surrounded by a bustling, larger world. Close by are the conveniences of modern life, but even now residents can still glimpse the beautiful views shared by the founding families of Bluff Park. And those pioneers have never left. Resting in a small cemetery first used by Summit Baptist/Bluff Park Baptist Church are members of the families that started the rich history of this small community. In 2003, Bluff Park Cemetery was listed in the Alabama Historic Cemetery Register. An inventory was recorded by Marion Carol Dickas of Girl Scout Troop No. 407. There are approximately 83 gravesites at the cemetery. (BluffParkAL.org)

FOUNDING FAMILIES AT REST. The following is a listing of each person at rest in the Bluff Park Cemetery: Acton, Curtis Harold; Alexander, Willie M.; Armstrong, Ada Virginia; Armstrong, Hawkins; Armstrong, Henry; Armstrong, Rosie E.; Bailey, Ola K.; Barnes, Mauddie F.; Brasher, Annie Myrtle; Brasher, Aubrey C.; Brasher, Concie A.; Brasher, Lucille P.; Brasher, Maggie L.; Campbell, Floyed J.; Campbell, Margaret L.; Campbell, William F.; Curl, Fannie D.; Dickerson, James C.; Dison, Elmore N.; Dison, N. Jordon; Dison, M.A.T.; Dison, Zella Thames; Goodwin, James M.; Goodwin, Luther T.; Goodwin, Thomas M.; Hale, Evan P.; Hale, Minnie Cross.; Hale, Nellie; Hale, Sophronia C.; Hale, William "M., Jr.;" Hicks, Sarah E. Tyler; Hubbard, Jimmie; Hubbard, John M.; Hubbard, Thomas J.; Jones, E.S.; Jones, Earnesteen; Jones, Lola May; Jones, Martin L.; Jones, Pearl W.; Jones, Winnie F.; Marable, Champion S.; Marable, Jimmie E.; McClintock, Eris S.; McClintock, Evie L.; McClintock, Horace R.; McClintock, John T.; McClintock, John A.; McClintock, Nancy; Moore, Blanche Dison; Moore, Hugh; Munkus, Bennie E.; Munkus, Betty; Munkus, Charles E.; and Munkus, M. (BluffParkAL.org.)

FOUNDING FAMILIES CONTINUED. Also resting at the historic cemetery are Archey Otey, Louis J; Otey, Mary F.; Perry, Delia A.; Perry, John W.; Pilgrim, Radar C. Robinson; Eula Hale; Sellers, Connie; Sellers, David L.; Sellers, J. A.; Sellers, Martha Jane; Sellers, Mollie; Sellers, W.H. (Rev.); Sellers, Walter Lee; Smith, Clinton P.; Smith, Frank M.; Smith, Jackson; Smith, Jeff Davis; Smith, S.A. Kilgore; Smith, William M. "Bud;" Tollett, Harwell; Tollett, Infant; Tollett, Marion Preston; Tyler, Mattie M. Hale; Tyler, William Marion; Wendt, Emmeline M.; Wendt, Oscar E.; Whitaker, Louise M.; and White, Ruby B. (BluffParkAL.org.)

ABOUT THE ORGANIZATION

BluffParkAL.org is about the Bluff Park section of Hoover, Alabama. The website first went online in August 2006. The site delivers news about events and happenings, and information about Bluff Park and has hosted many events like neighborhood watch meetings, community parties, and city council forums. In 2011, the site launched the Adopt-a-Soldier collections program to send care packages to soldiers who would otherwise not get them while overseas. The site is maintained locally, thus its slogan, "For, about and by Bluff Park, Alabama." The purpose of the site is to spread the word about the area and provide an online hub for residents.